IMAGES
of America

FILIPINOS IN CHICAGO

Estrella Ravelo Alamar and Willi Red Buhay

ARCADIA

Published by Arcadia Publishing,
an imprint of Tempus Publishing, Inc.
3047 N. Lincoln Ave., Suite 410
Chicago, IL 60657

Printed in Great Britain.

Library of Congress Catalog Card Number: 2001091433

For all general information contact Arcadia Publishing at:
Telephone 843-853-2070
Fax 843-853-0044
E-Mail sales@arcadiapublishing.com

For customer service and orders:
Toll-Free 1-888-313-2665

Visit us on the internet at http://www.arcadiapublishing.com

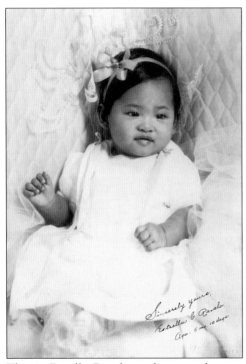

This is Estrella Ravelo at five months, ten days old.

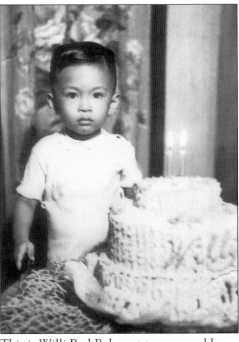

This is Willi Red Buhay at two years old.

CONTENTS

In loving memory of my husband, Justo; and my parents, Mr. and Mrs. Florentino Ravelo. My sisters, Flora, Pearl, and Gloria; and my brothers-in law. My nieces and nephews, Mr. and Mrs. Albert Viernes, Robin, Todd, Keith, and Jennifer.
—Estrella Ravelo Alamar

I dedicate this book to my mom, Delia Red Buhay-de la Rosa; and Tahanang Buhay. My brothers, Widivino and Waldomar; my sisters, Winifred and Wivinne; my nieces and nephews; and the Red Circle.
—Willi Red Buhay

ACKNOWLEDGEMENTS

My deep interest in the community of Filipino Americans in Chicago began to take shape in the 1970s, when I was elected president of the Nueva Vizcaya Association, which originated with my parents and others who came from the province of Nueva Vizcaya in northern Luzon, Philippines. My involvement extended to the Filipino American Council of Chicago, the umbrella organization of the community, and to other organizations. My late husband, Justo, and I gathered oral histories, photographs, and other memorabilia. Photo exhibits led to the founding of the Filipino American Historical Society of Chicago and eventually, with Willi Buhay, came the founding of the Filipino American Historical Society Museum. *Estrella Ravelo Alamar*

With gratitude to family and friends who inspired me, I pursued my desire to write this book. I have the continuing passion of preserving, documenting, and disseminating the immigration story of the first 100 years of Filipino American history. I was motivated to collaborate with Estrella Alamar to make this book a reality. *Willi Red Buhay*

We would like to acknowledge our families and many friends who have supported us spiritually, morally, and materially over the past 15 years in our mutual desire to research the history of Chicago's Filipino Americans. It is a labor of love that we have shared in time, energy, and money to collect and save, record and preserve our pictorial history.

Our mission is made possible by the contributions and encouragement of Mr. and Mrs. Albert Viernes and family, Alex Gonzales, Robin Alamar Abdullah, Keith and Jennifer Alamar, Karen Stobart, Stella Balesh, Julie Dumo, Connie and Millie Santos, Pacifico and Elvira Bacalzo, Sonia Bautista, Arlene Del Rosario, Susan Vitor, Elsie Sy-Niebar, Dr. Maria Acierto, Ruth Galinato, Joyce Garcia, Tony and Mila Abellera, Zeny Bungubung, Paul and May Rojas, Dr. Ruben P. Red, Dr. Rey de la Cruz, Ved Diamante, Dante Capallan, Manny Zambrano, Orly Bernardino, and Narciso Delfin.

We are truly grateful to other individuals, too many to mention, who have expressed wonderful words of appreciation of our projects and offered to assist us as we journeyed through the task of creating this work. There is a wealth of photographs we have gathered and many more to collect for future works.

Estrella Ravelo Alamar and Willi Red Buhay
Chicago, Illinois
May 15, 2001

INTRODUCTION

It was about time that Estrella Ravelo Alamar took out much of her precious archival materials in boxes at her overloaded South Side/Hyde Park home in order to be able to produce Chicago's first book on Filipino Americans, whose presence in the Windy City dates back to 1904.

That was the era of the *Pensionados*—Filipino students sent to America to attend major universities and colleges on a government pension. There on a contract they were to study various academic disciplines, and get baccalaureate and graduate degrees to prepare the Philippines for a democratic way of American-tutored life upon their return to the homeland. However, many did not return, and that is how Chicago's Filipino American history began. To us Browns, their history is our *Pinoy* legacy—Filipino American that is.

Ensconced in oral history and personal interviews, and some 240 photographs as old as 80 years, emerge the wonderful stories and memories of workers, students, United States veterans, Olympians, yo-yo champions, organizations, and a unique community life of the first-generation Philippine-born men and women, their families, and second-generation American-born children now responsible adult Chicagoans.

Of course, one must take into account that this Chicago history is not only about men but also women, among them *Filipinas* who with "filipinized" women—white, black, Latino, and other ethnicities, as wives and mothers—provided the heart and soul to a Filipino American society.

This pictorial history book could not have accomplished the full *Pinoy* history if not for one of Illinois' more distinguished artists in Willi Red Buhay, whose experiences particularly focus on the fourth immigration wave of Filipinos to the United States, starting in 1965. The designer-turned-author has been a hard-working colleague of Estrella Alamar in the Filipino American Historical Society of Chicago. That is the historical society where all this has come about, thanks to its co-founders—Estrella and her beloved, the late Justo Obaldo Menzen Alamar (1931–1998).

Filipinos in Chicago brings historical justice to the Windy City, whose Filipino American legacy is as rich as Seattle, Honolulu, and California's Stockton, San Francisco, Los Angeles, and vicinities. American historians should add to their litany of "Who's Who" the names of Alamar and Buhay. Certainly, the Filipino American National Historical Society has!

Dr. FRED CORDOVA
President Emeritus
Filipino American National Historical Society

One

THE EARLY DAYS

This is a postcard message from Florentino Ravelo, sent to Francisco Alayu at 5714 Kimbark Avenue, on December 1, 1920. The message reads as follows: "This is my early Christmas present to you in which you could study some of our early lives when we came into business first in America. Fraternally yours, Florentino Ravelo.

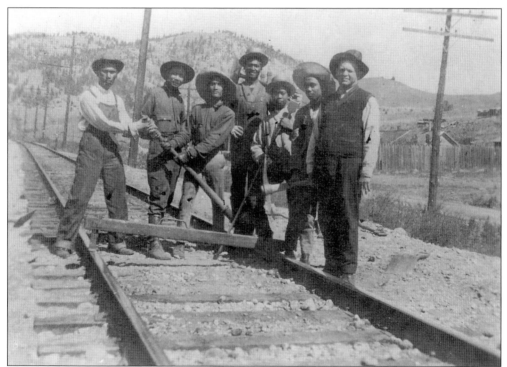

THE RAILROAD CREW. Some Filipinos worked on the railroad to get to Chicago. This photo was taken on August 10, 1920, in Bearmouth, Montana. The Chicago, Milwaukee, St. Paul Railroad Company was the first electric railroad in the United States. Members of this crew to lay the ties and rails are pictured left to right: Fidel Ramirez, Cristobal Pascual, Milquiades Santos, the Jackmen, Florentino Ravelo with shovel, Tobias Guinsatao with bar, Regino Conchino (cousin of Ramirez) the helper, and Bert Griswold the foreman.

YOUNG FRIENDS. Pictured are friends Emilio Menzen and Florentino Ravelo from Nueva Vizcaya, northern Luzon, Philippines. (Ravelo Photograph Collection.)

CHICAGO

*Be proud Chicago, for you have
in your town
One great people from Pearl
of the Orient Sun
These are the people with the
brown color skin
Learn from their skills
learn from their cheers
Learn from their sincerity
and hospitality
Sing with them their sweet songs
'cause sometimes they feel alone
Welcome them Chicago
open wide your arms
Be proud of these people
be proud of their toll
They are proud of you too dear,
old Chicago
In your town on your shore
They have found a new home.*

—Norma Manankil

YOUNG IMMIGRANTS. Third and fourth from the left, Johnny Padua and Timeteo Ravelo, traveled together from Nueva Vizcaya, Philippines, to Chicago. Motherless at a young age, Tim at age nine was encouraged to come to America by his brother Florentino. Tim stayed with family before establishing residence at the Duncan YMCA at 1515 West Monroe Street. When television was new, Tim enrolled for technical training at Coyne Technical Institute. He retired as a Yellow Cab driver. (Ravelo Photograph Collection.)

WINTER ARRIVAL. After a 19-day trip across the Pacific Ocean and a train trip across the United States, newlyweds Ambrosia Galutera Ravelo and her husband, Florentino, were greeted by a heavy snowstorm upon their arrival to Chicago in February 1935. Immigration law restricted Filipino immigration quota to 50 per year. Ambrosia was number 17. Their home was in the Garfield Park area at the Cordova Apartments, 1704 West Maypole Avenue, with other Filipino American families. (Ravelo Photograph Collection.)

FILIPINO ASSOCIATION OF CHICAGO (FAC). This was the first umbrella organization of Filipinos with headquarters in the Garfield Park area, 300 South Hamilton Avenue at Jackson Boulevard. The phone was "WEST 7259." The building had a barbershop, boarding rooms, and a meeting hall. Diary notes of Florentino Ravelo (seated, bottom right) recorded his operations as Clubhouse Manager while attending De Paul University Law School. In 1927, the officers were M.R. Cruz, President; C.S. Cornelio, Vice President; S. Aganad, Recording Secretary; A.P. Acierto, Corresponding Secretary; C.P. Torres, Treasurer; and F. Encarnacion, Sergeant at Arms. (Ravelo Photograph Collection.)

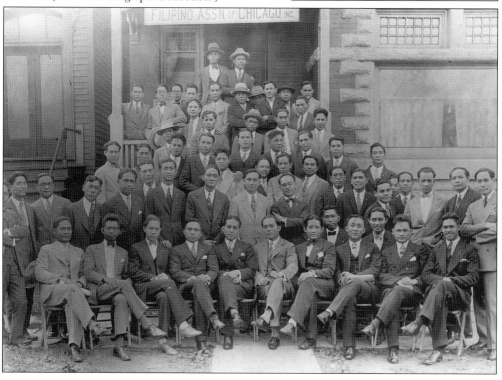

THE FILIPINO STUDENT

Vol. IX January - February, 1932 No. 4

WATCH YOUR STEP!

"One of the strongest pillars of Philippine society is the prominent role played by woman in the life of the nation and of the family." Mrs. Ildefonsa C. Osias.

THE FILIPINO STUDENT PUBLICATION, January-February issue, 1932. *The Filipina*, depicted by the artist, Manuel Reyes Isip, is shown on the cover. The Filipino Students Christian Movement in America, 347 Madison Avenue, New York City, published this publication. Manuel A. Adeva was the editor. The subscription fee was $1 a year or 15¢ a copy. It carried news from coast to coast about Filipino communities. (Ravelo Photograph Collection.)

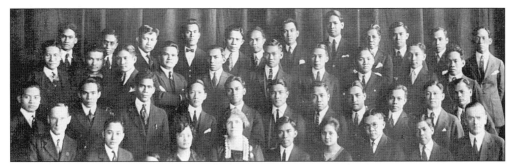

PENSIONADOS. Government-supported students referred to as *Pensionados* are pictured at the University of Illinois, Urbana, Illinois, in 1921. *Pensionados* and self-supporting students were enrolled in other universities: University of Chicago, DePaul University, and Roosevelt University.

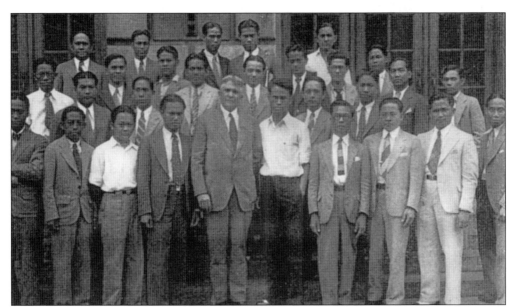

RICHARD T. CRANE HIGH SCHOOL AND COLLEGE. The college is located at Oakley and Jackson Boulevards. Shown here are the Filipino Club members in the August 1930 yearbook. Students combined work and education into their daily schedules.

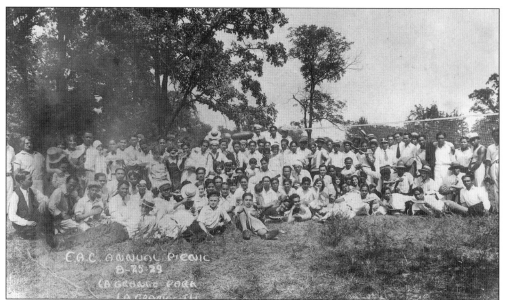

PICNIC. La Grange Park, La Grange, Illinois, provided the country setting for the Filipino Association of Chicago (FAC) Annual Picnic on August 25, 1929.

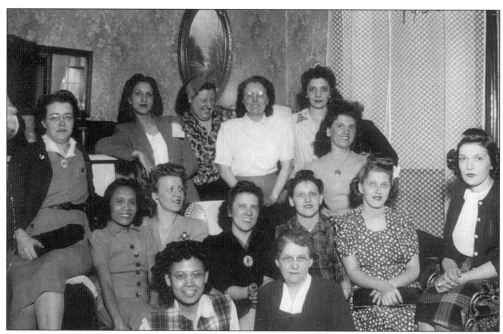

THE UNITED LADIES CLUB. This organization, founded by women of various ethnic backgrounds who married *Pinoys*, focused their family life within the Filipino community. This picture was taken in 1945. They are, from left to right: (top) Mrs. Guillermo, Mary Casipid, Eva Castillo, Lena Guillermo, and Irene Catolico; (bottom) Mrs. Tolentino, Venancia Samonte, Helen Rocca, Connie Santos, Sonia Posadas, Mrs. Tolentino, Lucille Soriano, Jeanette Mendoza, and June Ayson. (Bautista Photograph Collection.)

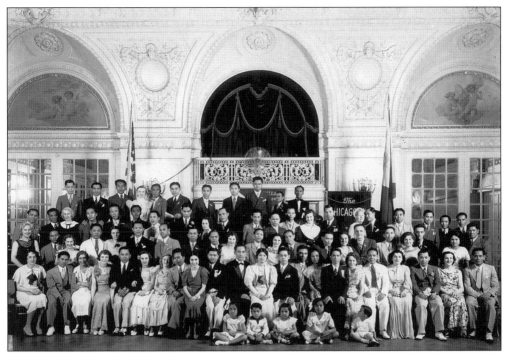

THE NUEVA VIZCAYA ASSOCIATION OF CHICAGO. The Fourth Inaugural Dance of this provincial club was held at the Hotel Sherman on June 2, 1935. The NVA still exists as a vibrant organization today as it approaches its 70th anniversary. (Ravelo Photograph Collection.)

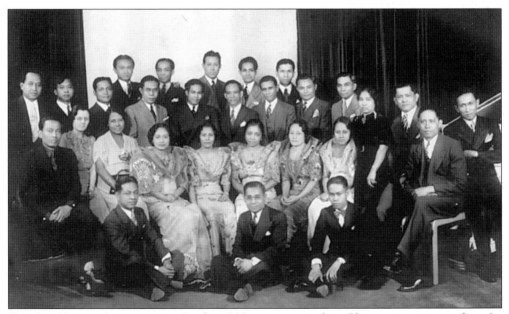

THE LA UNION ASSOCIATION. In the 1920s, upon arrival to Chicago, immigrants from La Union Province settled in Hyde Park on Harper Avenue near 57th Street, and in the Garfield Park area near the Chicago Stadium on West Madison Street.

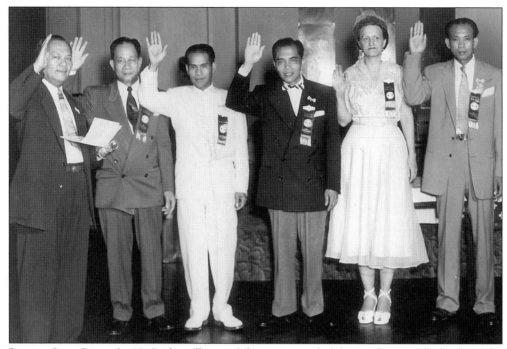

ILOCOS SUR CLUB. In 1947, the officers of this provincial club are photographed taking the oath of office. Shown left to right are Dr. Potenciano Varrilla administering the oath; Juan Gerospe, Treasurer; Federico Urian, Vice President; Mariano Cejalvo, President; Mary Pascua, Secretary; and George Sabado, Sgt. of Arms.

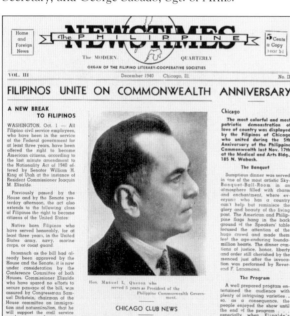

THE PHILIPPINE NEWSTIMES, DECEMBER 1940. This publication, printed in Chicago, Illinois, was a quarterly organ of the Filipino Literary-Cooperative Societies. It was sold for 5¢ a copy. Home and foreign news were featured. (Ravelo Photograph Collection.)

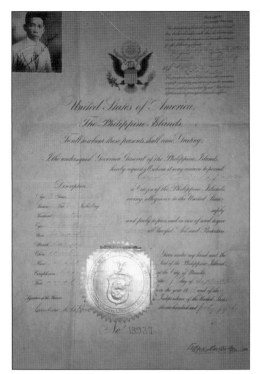

PASSPORT. Candido de la Rosa, a relation to the national hero, Dr. Jose Rizal, came to the United States in 1920. His passport reads, "United States of America, The Philippine Islands," with the signature of the Governor General of the Philippine Islands, Francis Burton Harrison. At Loyola University, he received a degree in Philosophy and Letters, then completed La Salle School of Law. (Tahanang Buhay Photograph Collection.)

IMMIGRANT. Shown here is *pensionado* Candido de la Rosa in 1923 in Chicago.

HONORARY RECOGNITION. Candido de la Rosa, who attained an administrative position, was employed at the Chicago Main Post Office from 1923 to 1959. In addition to honorary recognition given to retirees, the Postmaster General, Arthur E. Summerfield, presented him a silver watch and a certificate of honor. He also received a scroll honoring him for his esteemed friendship, loyalty, and goodwill toward his fellow postal coworkers. (Tahanang Buhay Photograph Collection.)

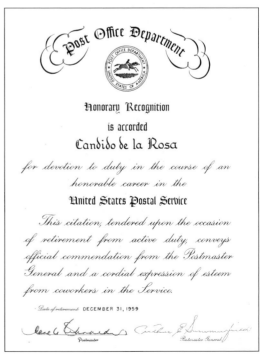

Post Office Department

Honorary Recognition

is accorded

Candido de la Rosa

for devotion to duty in the course of an honorable career in the

United States Postal Service

This citation, tendered upon the occasion of retirement from active duty, conveys official commendation from the Postmaster General and a cordial expression of esteem from coworkers in the Service.

Date of retirement DECEMBER 31, 1959

Postmaster Postmaster General

ROCKEFELLER SCHOLAR. Julita V. Sotejo, a graduate of the University of the Philippines Law School, came to the University of Chicago to continue her studies in nursing administration. When World War II broke out, she remained in the United States until 1946. She returned home to a life-fulfilling career as Dean of the University of the Philippines School of Nursing. (Ravelo Photograph Collection.)

GARFIELD PARK FLOWER CONSERVATORY. Many Filipinos and their families visited this Chicago Park District greenhouse in Garfield Park often. Viewing the tropical plants typical to the Philippines often made them long for the homeland. Banana trees, bougainvillaea flowers, and other rare plants could be seen. Park visitors in the photo are Mrs. Nena Lopez and Estrella Ravelo. (Alamar Photograph Collection.)

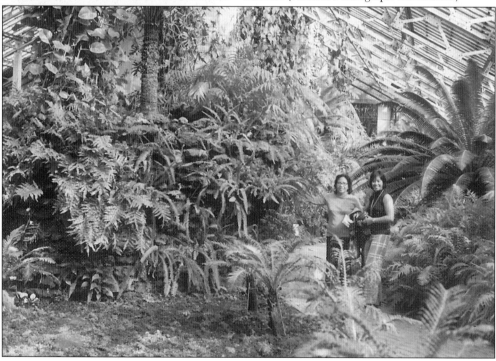

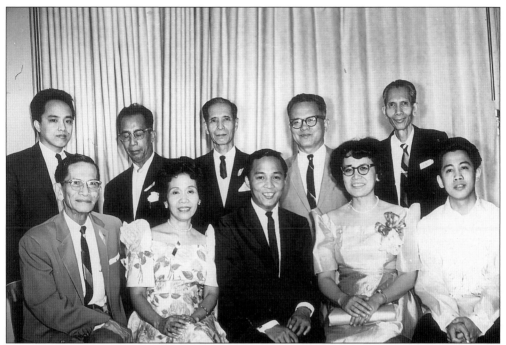

ILOCOS NORTE CLUB. Ilocos Nortenian officers pictured *c.* 1970 are, from left to right: (standing) Mr. Omanus, Victor Santos, Polly Batuyong, Benny Batuyong, and Henry Ocampo; (seated) Dr. Severo Guerrero, Paz Saladino, Philip Onagan, Connie Santos, and Ron Santos. (Photograph by Cedric S. Esta.)

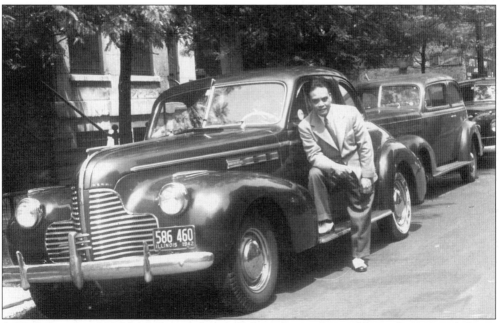

A NEW CAR. In 1942, Vidal Vitor is shown all dressed up in front of the early 1940s stylish car. *Pinoys* (as Filipinos were called) enjoyed posing like Vidal. Usually photos in postcard form were made to send back home to the family in the Philippines. (Vitor Photograph Collection.)

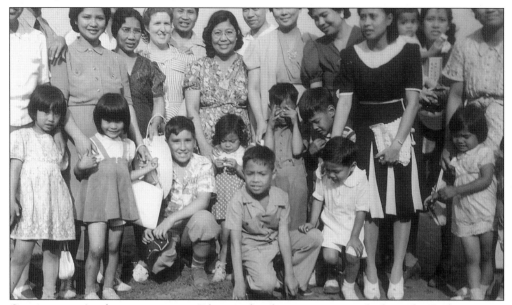

COMADRES. A closeness among Filipino families was nurtured through Godparent or *Compadre/Comadre* relationships. Some of the *Comadres* pictured here, from left to right, are: Melchora Alayu, Mercedes Guinsatao, Mrs. Cabanban, unidentified, unidentified, Mary Cornelio, Irene Valencia, Eleuteria Lagasca, Pompeia Ponce, Julita Gonzales, and Ambrosia Ravelo. The children, from left to right, (by first names) are: Estrella, Margarita, unidentified, Shirley, Tommy, unidentified, Richard, Don, Flora, and Perlas. (Ravelo Photograph Collection.)

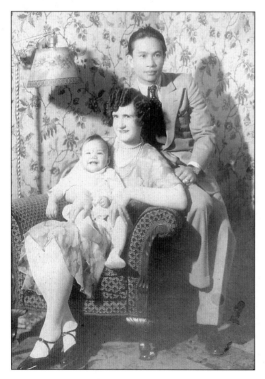

AMERICAN FAMILY. This photo, taken in the 1930s, shows Ignacio Panuncialman (from the Visayas) with his wife, Marie, and son, Robert. It portrays the typical Filipino American family of the early era. (Cepeda Photograph Collection.)

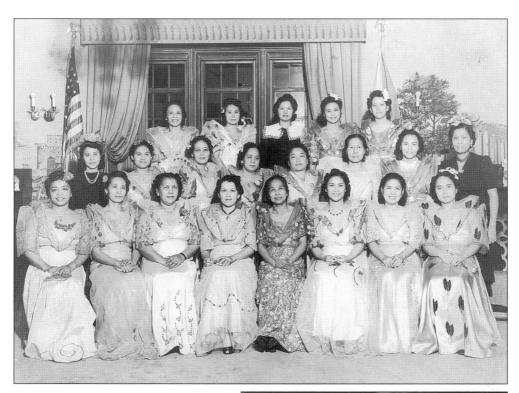

PHILIPPINE WOMEN'S CLUB. Filipinas dressed in their finest native dress for special occasions. This event was held at the International House at the University of Chicago on November 8, 1942. Pictured, from left to right, are: (top) Mrs. Venancia Samonte, Mrs. Biason, Mrs. Rita Colcol, and Mrs. Julita Gonzales; (middle) Mrs. Pompeia Ponce, Mrs. Ambrosia Ravelo, Mrs. Guillerma Rivera, Mrs. Antonia Dacanay, Mrs. F. Ceralde, unidentified, Mrs. Mary Vergara, and Mrs. Paz Garcia; (seated) Mrs. Bacalzo, Mrs.Gregoria Alamar, Miss Julita V. Sotejo, Mrs. S.V. Arnaldo, Mrs. Melchora Alayu, Miss Gabino, Miss Julita Murillo, and Dr. Leonore Bueno. (Ravelo Photograph Collection.)

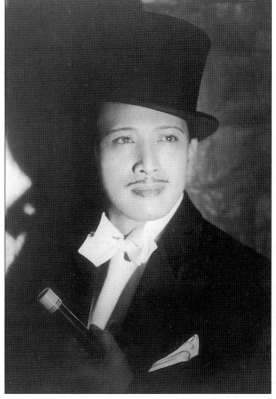

PHOTOGRAPHER. Looking debonair is Rudy Luciano. He was an official photographer of the Filipino-American community. This portrait was taken by photographer Peter Galang. (Alamar Photograph Collection.)

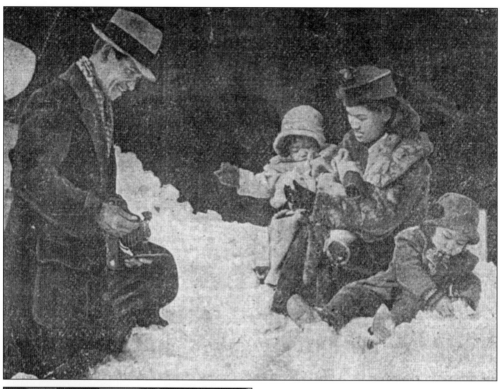

WINTER FUN. A *Chicago Tribune* photographer caught the Florentino Ravelo family experiencing the deep snow in Garfield Park in February 1939.

CO-DIRECTORS. Reverend Fernando Laxamana and Mrs. Melchora Alayu were reunited in 1987, in DeKalb, Illinois, to reminisce about their roles as co-directors of the Filipino Community Center, which was located at 640 South State Street in Chicago from in the early 1940s. Among the social services the center provided to Filipinos were: search for housing, financial assistance, food provisions, and educational resources. (Alamar Photograph Collection.)

Two

FAMILY AND
COMMUNITY

The love for family, a deeply rooted tradition, is part of every Filipino's values. First comes love of God and country, followed by love of family. The natural love for family and neighbors comes second nature to Filipinos and is instilled in Filipino-American life in the United States. With very close family ties, a household may consist of the core family and extend out to other relatives.

The growth and development of the community over the years speak of Filipinos in Chicago having the pride of claiming the first Filipino-owned center in the whole North America, which is the Dr. Jose Rizal Memorial Center at 1332 West Irving Park Road, Chicago, Illinois.

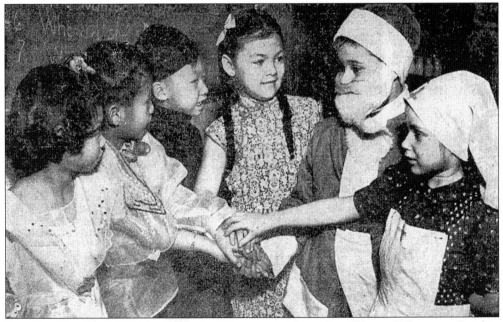

CHILDREN OF ALL NATIONS. This picture appeared in the *Chicago Tribune* on Sunday, December 20, 1942. Estrella Ravelo and Rudolph Rivera, first-grade students at Ray Elementary School, wore the Philippine native costumes for a special program featuring children of 13 nationalities. (Ravelo Photograph Collection.)

FILIPINO-AMERICAN ASSOCIATION
NATURALIZATION CELEBRATION

S O U V E N I R P R O G R A M

ST. CLAIR HOTEL
Chicago, Illinois

Thursday, September 5, 1946
6:30 P. M.

NATURALIZATION CELEBRATION. The May 1, 1934, Tydings-McDuffie Act guaranteed independence to the Philippines in 10 years. Status of Filipinos in the United States changed from American nationals to aliens. Then in 1946, Filipinos in the United States may become U.S. citizens. To celebrate this historic occasion, the Filipino American Association held a naturalization celebration at the St. Clair Hotel on September 5, 1946. (Ravelo Photograph Collection.)

U.S. CITIZENSHIP. Many members of the Filipino Postal Club were among the first group of Filipinos to take the oath of citizenship. (Ravelo Photograph Collection.)

87 Filipinos Take Oath of U. S. Citizenship

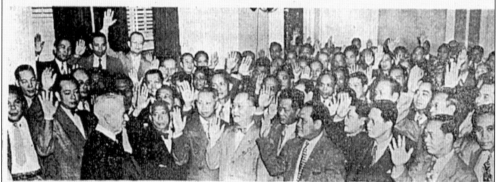

Federal Judge Holly administering the oath of citizenship to 87 Filipinos in the federal buildi yesterday.
[TRIBUNE Photo]

New Law Applies

Federal Judge William H. Holly yesterday administered the oath of citizenship to 87 Filipinos who were the first in this district to become citizens under the new federal provision allowing Filipinos to become citizens. Most of the group were members of the Filipino Postal club and are employed at the postoffice. Last night the group held a banquet and dance at the St. Clair hotel.

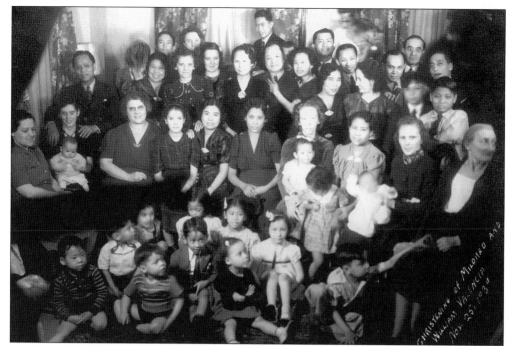

CHRISTENING PARTY. The parents of Mildred and Bob Valencia celebrated this religious occasion with a christening party at their home near the Chicago Stadium. Among the friends and relatives present were Connie Santos, Bob Valencia, Delores Lardizabal, the Cabanban families, the Garcia family, and others. Some of the children recognized are Orlando Cabanban and Sally Garcia.

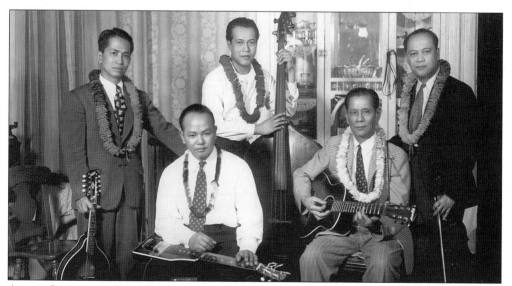

ALOHA ISLANDERS ORCHESTRA. In this musical combo, from left to right, are: (standing) Leo Afalla, Celestino Alayu, and Lawrence Banag; (seated) Albert Viernes, and A. Soriano. They were town mates from Solano, Nueva Vizcaya. The group entertained in the 1930s, in a nightclub in Summit, Illinois, on weekends and played at the Nueva Vizcaya Association parties. (Viernes Photograph Collection.)

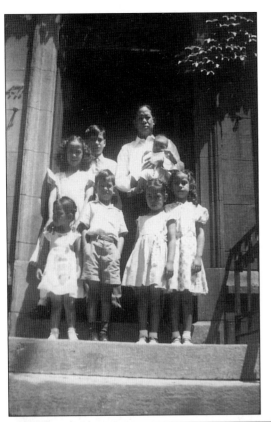

THE TALLUNGAN FAMILY. Pictured here are six of twelve Tallungan children with their father. Manuel and Mildred Tallungan and family resided in their own home at 5471 South Ellis Avenue in the Hyde Park neighborhood for many years. (M. Suarez Photograph Collection.)

CHRISTMAS CHILD. Experiencing their first Christmas in the United States are Ethel and Ronald Viernes in 1953. The picture was taken in their apartment on the South Side. To the fascination of his cousins of the Ravelo family, Ronny, age three, could only speak the native language, Ilocano, when he first arrived from the Philippines.

CVS Sweetheart. In 1948, the seniors at Chicago Vocational High School selected Gloria Ravelo as one of the class sweethearts to reign at the Sweetheart Dance. She pursued a major in secretarial science, excelling above average in stenography and typing. Gloria was among the top 10 graduates of her class.

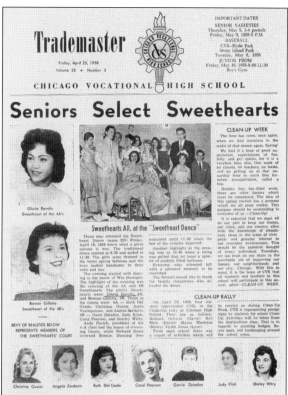

Boy Scouts. In 1968, 11-year-old Richard and 10-year-old Victor White (Ravelo family) joined the Boy Scouts. They are pictured on the front steps of their grandparent's home at 5472 South Dorchester Avenue in Hyde Park before leaving for summer camp at Camp Wolverine in southwest Michigan. They belonged to Troup No. 599, based at Sinai Temple at 54th Street and South Shore Drive.

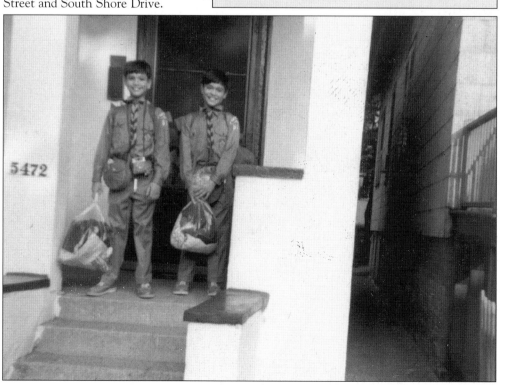

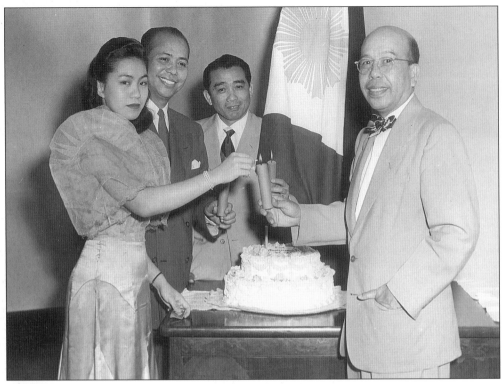

INDEPENDENCE OF THE PHILIPPINES.
Celebrating the second anniversary of
Philippine independence with Consul
Leopoldo Ruiz in 1948 are Virginia Ruiz,
Vice Consul Rosal, and Resti N. Paulo.
(Paulo Photograph Collection.)

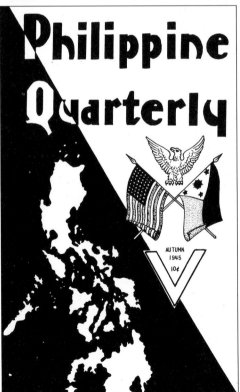

PHILIPPINE QUARTERLY. This was a major
Chicago publication in the 1940s.

TEENAGERS. White bobby sox were trendy in the 1940s. Pictured at the Valencia home are Filipino Youth Organization members, from left to right: (top) Millie Valencia, Jimmy Valete, and Marilyn Ayson; (seated) Phyllis Garcia, Pacifico Bacalzo, and Delores Hidalgo. The group's advisor was Mrs. Mary Cornelio. (E. Bacalzo Photograph Collection.)

PROM NIGHT. A highlight of one's high school years is to attend the Senior Prom. Elvira Bacalzo, a student at Providence High School in the 1960s, is with her prom date, Frank Jaramillo. (E. Bacalzo Photograph Collection.)

DON'T FORGET — YOU are INVITED

to attend the

First
Philippine - American Bowling League

Get - Together DANCE

... at the ...

LAKEVIEW BALLROOM
3239 North Clark Street

•

SUNDAY, February 18, 1951
9:30 p.m. to 1:00 a.m.

•

MUSIC BY BEN SHARP ORCHESTRA
(IN PERSON)

IMPORTANT:-

You and the Youngsters can now join our expanding League which is already
Sanctioned by the BOWLING LEAGUE OF AMERICA

IT'S A DATE — Dancing — GOOD MUSIC — GOOD CROWD — LOADS OF FUN

DANCING AT THE LAKEVIEW. The Lakeview Ballroom at 3239 North Clark Street (near Belmont) was a popular location for Filipino American social events. This is an announcement of a dance sponsored by the Philippine American Bowling League on February 18, 1951. (Ravelo Collection.)

THE FIRST PICNIC OF THE SEASON. Families anxiously anticipated the long drive to Geneva, Illinois, each summer. Before expressways were built, it took as long as two hours from some points in the city to get to Geneva. It was a ritual every year to gather for the big community picnic. Families and friends greeted each other to share stories, laughter, and good food. There were games for every age group that filled the day from morning to sundown. The last event was dancing under the stars in the big pavilion with a live band.

THE FIRST FILIPINO UNITED CLUBS PICNIC FOR 1953
AT GOOD TEMPLAR PARK, GENEVA, ILLINOIS
SUNDAY, JULY 19, 1953

FREE DANCING
FROM 6:00 P.M.
TO 9:00 P.M.
MUSIC BY
MR. IRV DULCY

VARIOUS GAMES
FOR CHILDREN
and ADULTS
WITH PRIZES
AWARDED TO
EACH WINNER
10:00 to 5:00 P.M.

FIRST FAMILY OUTING
PRIVATE PARK, WIDE AREA FOR PLAYGROUND, PARKING SPACE, SPACIOUS HALL FOR DANCING IN THE PAVILION. DELICIOUS FOOD, LECHON, CALDING AND SOFT DRINKS TO BE SERVED IN THE RESTAURANT.
FREE ADMISSION FOR ALL CHILDREN AND TEEN-AGERS
UNDER 13 YEARS OLD — ADULTS, $0.75

Sponsored by
Filipino Bachelors' Club of Illinois
MR. PEDRO DE LEON, President — Social Chairman: MR. C. R. ACOSTA
MR. P. ANCHETA

Ilocos Nortenian Association
DR. SEVERO R. GUERRERO, President — Social Chairman: MR. H. OCAMPO

Ilocos Sur Club
MR. SOSIMO PASCUA, President — Social Chairman: MR. JOSE CARINO
MR. R. CENTENO

Postal Club
MR. EUGENE ESTACION, President — Social Chairman: MR. B. RIVERA
MR. P. E. DE LEON

United Ladies' Club
MRS. LILLIAN PASCUAL, President — Social Chairman: MRS. C. SANTOS

United Pangasinanes of Chicago, Inc.
MR. ANTONIO ANDRES, President — Social Chairman: MR. M. MARAMBA

ROUTE: Follow Roosevelt Road going West (about 35 miles) to Geneva, Illinois - - - -
turn to your right before you come to grocery store - - - drive 500 yards to the gate.

GOOD TEMPLAR PARK — GENEVA, ILLINOIS

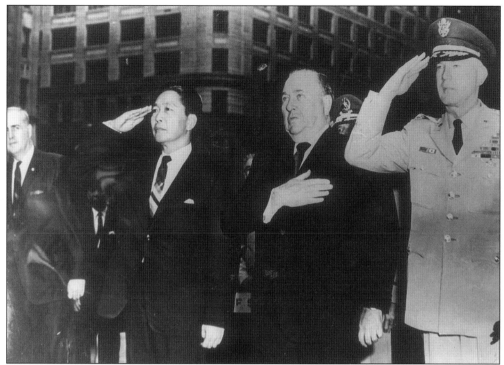

PRESIDENT MARCOS VISITS CHICAGO. After President Ferdinand Marcos was elected to his first term of office, he came to the United States to address the U.S. Congress in Washington, D.C., and he made an official visit to Chicago. Mayor Richard M. Daley welcomed the Philippine president.

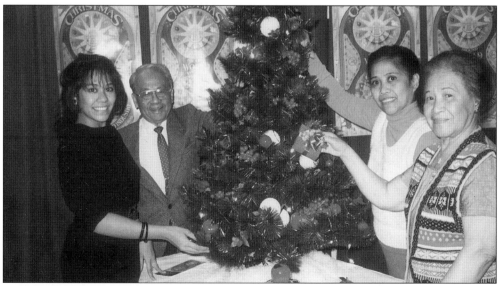

CHRISTMAS AROUND THE WORLD. Decorating a miniature of the Philippine Christmas tree are Grace Mittenthal, Carme Llapitan, Rosemary Mittenthal, and Ann Llapitan. They also participated in a musical on behalf of the Filipino-American community in the ethnic Christmas programs of the museum. (Llapitan Photograph Collection.)

PORTRAIT OF A LEADER. Carmelito Llapitan immigrated to the United States in 1923, as a self-supporting student. He worked and attended school at Crane College. He eventually obtained a degree in Business Administration at Roosevelt College. He and his wife, Angelita, will be remembered among Chicago's most dedicated Filipino-American community leaders. (Llapitan Photograph Collection.)

TRIBUTE TO A COMMUNITY LEADER. Mrs. Angelita Llapitan, widow of the late Carmelito, accepts a replica of the honorary street sign, Carmelito Llapitan Court, from Mayor Richard J. Daley. Also present were Asian American Commissioner Rudy Urian and a Filipino American mayoral media staff member. Carmelito Llapitan Court is the honorary name designated to the street at 1300 North Irving Park Road at Rizal Center. (Llapitan Photograph Collection.)

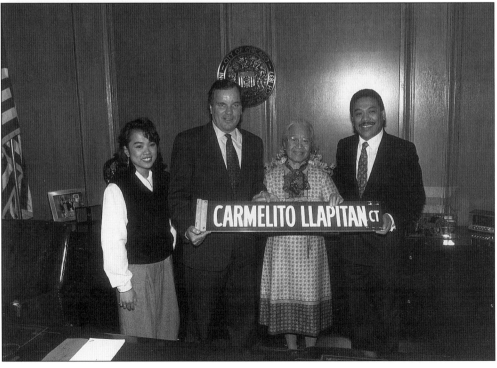

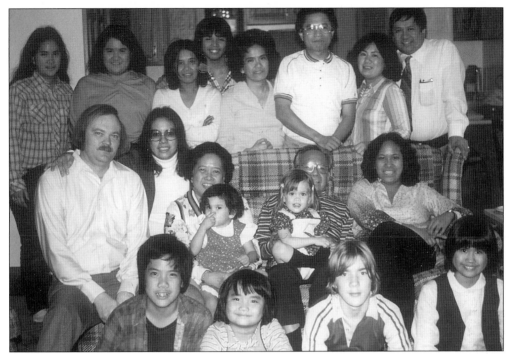

GONZALES-CRUZ FAMILY. In 1978, the three generations of this Filipino-American family celebrated Thanksgiving Day in Lafayette, Indiana. They are, from left to right: (top) Cecilia Aguto, Caroline Gonzales, Johnny Tolentino, Remy, Antonio Aguto Sr., and Izumi and Alex Gonzales; (middle) Marty and Rosie Weaver, Julita Cruz, Stefi and Jennifer Weaver, Rosauro Cruz, and Corazon Cruz; (bottom) Antonio Aguto Jr., Linda Gonzales, Matthew Weaver, and Paula Gonzales. (Ravelo Photograph Collection.)

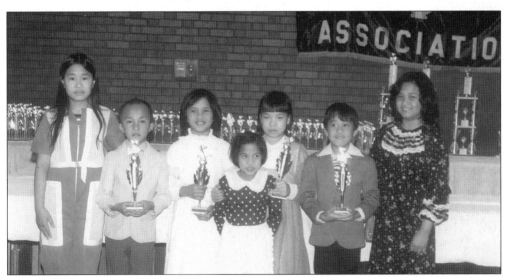

PIANO RECITAL. Filipino children were encouraged to learn to play the piano at an early age. Pictured here to receive their trophy awards, left to right, are the Del Valle and Gatan children: Michelle Del Valle, Romar Gatan, Marose Gatan, Maridoll Del Valle, Vianni Gatan, Michael Del Valle, and Missy Del Valle.

PUBLIC SCHOOL. Justo Obaldo Menzen Alamar (1931–1998) (bottom, third from left) is pictured in his third grade class at Oakenwald School on South Lake Park Avenue on Chicago's South Side. He often told stories about the "39th Street and Lake Park neighborhood." Many Filipinos, including the Alejandro Gonzales family, were neighbors. (Alamar Photograph Collection.)

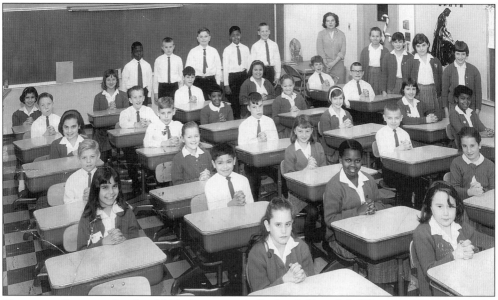

CATHOLIC SCHOOL. In this 1965 class picture, Richard (Ravelo) White can be seen as the student sitting in the second row, second seat from the front. He is in class at St. Philip Neri Catholic School in Room 103. He is an alumni of Mt. Carmel High School and the School of Engineering at the University of Illinois, Circle Campus. (Ravelo Photograph Collection.)

LOLA. Filomena de la Rosa-Paguinto Red came to Chicago to join her brother, Candido de la Rosa. A noted artist, poet, and sculptress, she made her home in Chicago. Her colorful life includes work as a church volunteer and accomplished artist. She also enjoyed writing until her death in October 2000, at the age of 98. (Tahanang Buhay Photograph Collection.)

LOVE OF ELDERS. One of the traits of Filipinos brought to the Filipino community in the United States is the "Love of Elders." Filomena de la Rosa-Paguinto Red is with her daughter, Delia Red Buhay, her son, Dr. Ruben Red, and her niece, Annie Perez. (Tahanang Buhay Photograph Collection.)

35

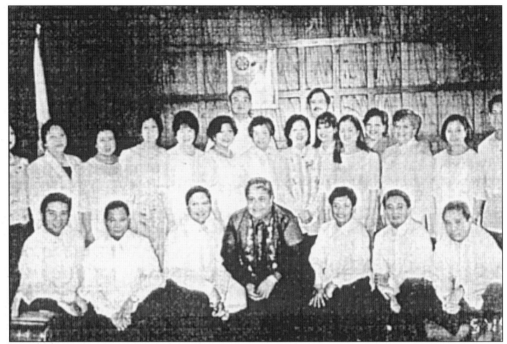

CONSULAR STAFF. Consul General Emelinda Lee-Pineda joined the consular staff in Chicago in 1998. Also pictured are Consul Eduardo Malaya and Vice Consul Adelio Cruz. This photograph of the consular staff is taken at the offices located at 30 North Michigan Avenue, Suite 2100, Chicago, Illinois 60602.

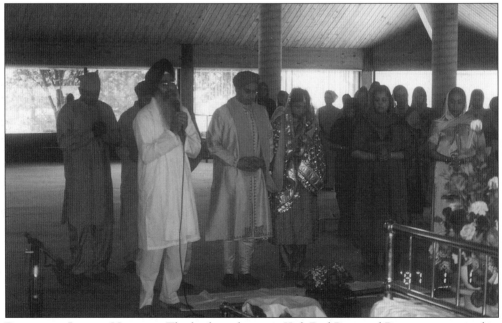

PHILIPPINE-INDIAN NUPTIAL. The bride and groom, Kirk Red Papa and Pancy, were united in marriage in two wedding ceremonies in 1999. Pictured is the wedding ceremony at the Sikh Temple in Palatine, Illinois. (Tahanang Buhay Photograph Collection.)

36

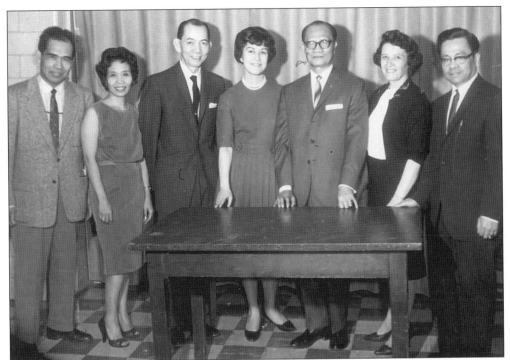

FACC Officers. Pictured are the 1975 officers of the Filipino American Council of Chicago. FACC headquarters were located at Webster Avenue. Pictured from left to right are Primo Mendoza, Paz Saladino, Gelacio Canapi, Angeline de Castro, President Jose Leonidas, Susan Vitor, and Carmelito Llapitan.

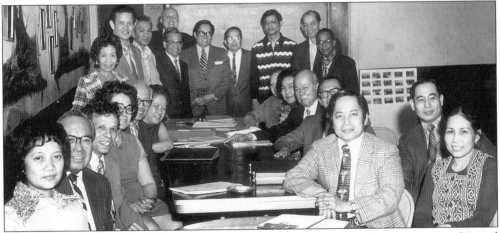

FACC Board of Trustees. In 1974, the Board of Trustees of the Filipino American Council of Chicago is photographed planning the purchase of the Dr. Jose Rizal Memorial Center at 1332 West Irving Park Road, Chicago, Illinois 60613. Pictured, from left to right, are Irene Batuyong, Rosauro Cruz, Robert Mittenthal, Connie Santos, Nick Nitafan, Julita Cruz, Paz Saladino, Quevedo, Dr. Vincent Battung, Alderman John Hoellen, Carmelito Llapitan, Alex Gonzales, Alexander Gonzales, Dr. Rene Tanquilut, Gelacio Canapi, Victor Santos, unidentified, Maria Acierto, Silverio Sol, unidentified, Dr. Andres Botuyan, Florencio Villegas, and Geline Tanquilut.

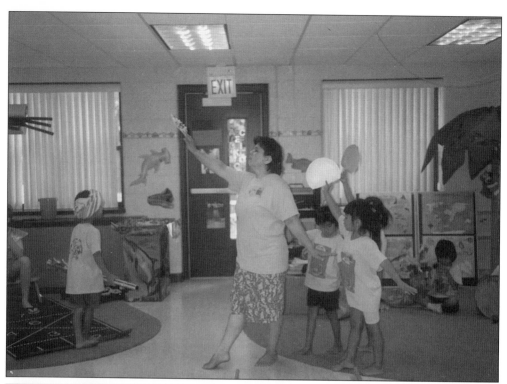

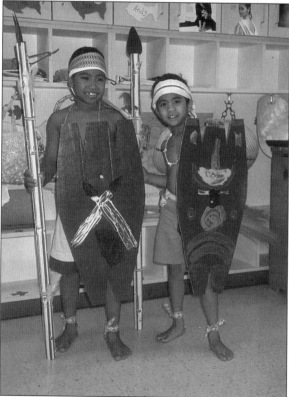

HANDS AROUND THE WORLD (HATW). In July 1995, Edna Ratio is demonstrating Philippine dance steps to the children at the HATW summer camp. Adopted children meet once a year for one week to participate in Philippine activities. The program includes the arts, language, and food. Edna Ratio is a principal at the Jacqueline Kennedy Elementary School in Burbank, Illinois. (Alamar Photograph Collection.)

ROLE-PLAYING. This photo, taken in July 1995, shows two HATW students dressed in native costumes they designed for their camp's culminating activity. (Alamar Photograph Collection.)

Three
CULTURAL ARTS

Chicago and the surrounding areas abound with a wealth of Filipino American and Philippine talent. Many Filipino visual artists have made Chicago their home base for artistic endeavors. Many are working in the fields of graphic design, fashion, the fine arts of painting, sculpture, and design, and the culinary arts. Performing artists also find Chicago as the main stage for their artistic expressions. Artists in allied arts also find many opportunities for their creative exercises. There are regular exhibitions of artworks and renditions of performances year round in various galleries, museums, libraries, theaters, and private venues. Themes reflect the rich cultural traditions in every aspect.

MUSIC AT HOME. This photo was taken in 1950. The Bacalzo brothers, Pacifico on saxophone, Conrado at the piano, and Felino with the guitar are at their home at 1749 West Warren Boulevard across the street from the Chicago Stadium. The three teenagers were students at McKinley High School.

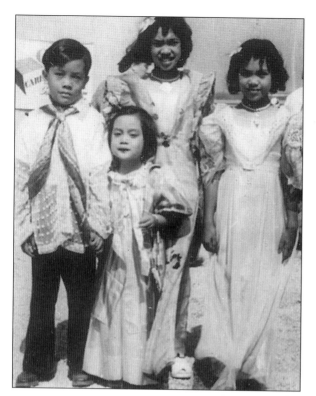

CHICAGO'S RAILROAD FAIR. In 1950, Arthur and Rosemarie Dacanay, with Perlas and Gloria Ravelo, were presented in the Culture Show on the lakefront. Over the years, each generation of young Filipino-American children contributed Philippine performances to civic functions throughout the city.

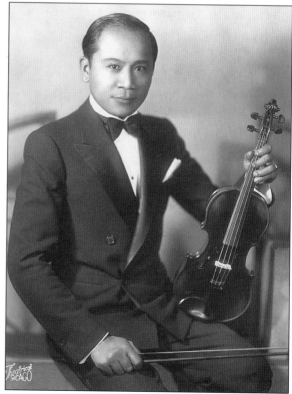

VIOLINIST, MAX RIDAO. Mr. Ridao will be remembered as a refined gentleman. He was an accomplished violinist and a music composer. He was also known for his beautiful calligraphic handwriting.

MUSICIAN OF THE 1930s ERA. Jose "Pat" Nagar was the first Filipino bandleader with American musicians. He was a songwriter, musical composer, and big band leader. "Pat" was the featured pianist with the Xavier Cugat Orchestra, which played regularly at the Edgewater Beach Hotel. He was the brother of Julie Nagar Cruz. He died in 1945, in Detroit, Michigan. (Cruz Photograph Collection.)

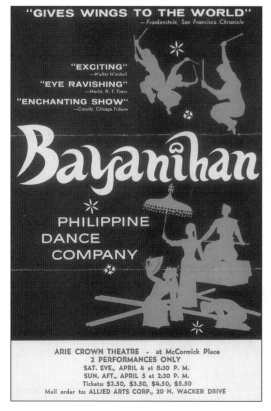

BAYANIHAN. The professional Philippine Dance Company from the Philippines has been on international tours over the years. The first performance in Chicago took place at the first Arie Crown Theatre at McCormick Place.

FIESTA FILIPINA EXTRAVAGANZA. On June 1, 1952, The Filipino Catholic Guild presented *Fiesta Filipino* at the Eighth Street Theatre on Wabash Avenue. Among the performers pictured are Pacifico and Felino Bacalzo, Alex Gonzales, Victor Mariano, Bob Aranita, Loretta and Jeanette Clemente, Norma Lopez, and Loralei Castillo. Father Leyden was the Spiritual Director. Old St. Mary's Church has a long history with the Filipino community. The Paulist Fathers have served as Chaplains to the Guild since 1927. (Ravelo Photograph Collection.)

FILIPINO AMERICAN DANCE ARTS (FADA). The children were trained to dance Philippine traditional dances and ballet selections. FADA had an active dance school at the Filipino American Council of Chicago's Dr. Jose Rizal Center in the 1970s and '80s under the direction of the Mittenthal and Villegas families.

NUTCRACKER SUITE. Scott Alamar performed for four years in the Chicago Tribune's Nutcracker Suite Ballet at the Arie Crown Theatre in McCormick Place. He danced as one of the young party boys for three years. In December 1982, at age 12, he won the coveted role as prince. (Alamar Photograph Collection.)

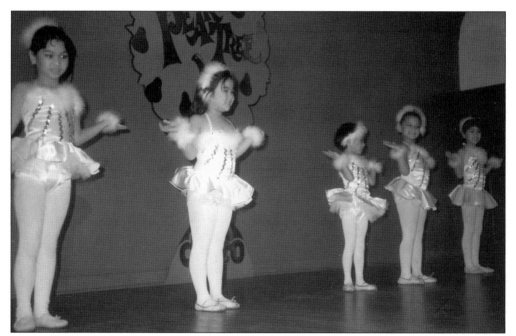

FADA. Shown here is a ballet performance of the children enrolled in the Filipino American Dance Arts. The number is part of a cultural presentation performed on December 23, 1980. (Llapitan Photograph Collection.)

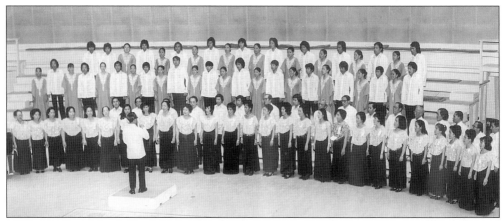

PHILIPPINE CHORAL SOCIETY. Under the director Dr. Wesley Tabayoyong the Philippine Choral Society was established in the 1970s as one of the community's first choral groups. This photograph was taken showing the group in concert at the Chicago Orchestra Hall.

HERMOSA DANCE TROUPE. Established by Mariano and Fe Hermosa in 1968, the dance troupe was composed of doctors and nurses who came to America under the Exchange Program. In the photograph, they are performing the Tinikling dance.

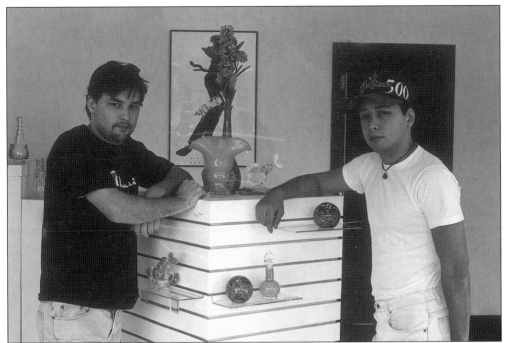

GLASS SCULPTURE. Third-generation Filipino-American artists Brian and Allen Cepeda specialize in the art of glassblowing. They are shown with a display of their creations. (Tahanang Buhay Photograph Collection.)

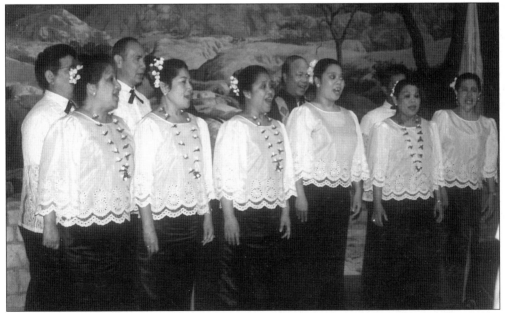

SAMPAGUITA SINGERS. This performance in June 1997 took place at the Consulate's reception held at the Field Museum. Pictured from left to right are: (top) Julian Banzon, Tong Gonzales, Ruben Suico, and Miguel Fernandez; (bottom) Petit Quinol, Nila Gonzales, Rosemary Mittenthal, Christine Cadlaon-Cabiltes, Ampy Basa, and Rosie Danguilan.

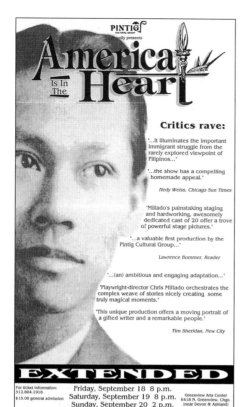

Critics rave:

"...it illuminates the important immigrant struggle from the rarely explored viewpoint of Filipinos..."

"...the show has a compelling homemade appeal."

Hedy Weiss, Chicago Sun Times

"Millado's painstaking staging and hardworking, awesomely dedicated cast of 20 offer a trove of powerful stage pictures."

"...a valuable first production by the Pintig Cultural Group..."

Lawrence Bommer, Reader

"...(an) ambitious and engaging adaptation..."

"Playwright-director Chris Millado orchestrates the complex weave of stories nicely creating some truly magical moments."

"This unique production offers a moving portrait of a gifted writer and a remarkable people."

Tim Sheridan, New City

EXTENDED

For ticket information:
312.804.1916
$15.00 general admission

Friday, September 18 8 p.m.
Saturday, September 19 8 p.m.
Sunday, September 20 2 p.m.

Greenview Arts Center
6418 N. Greenview, Chgo.
(near Devon & Ashland)

AMERICA IS IN THE HEART. This poster features the critics' comments of Pintig's play, *America is in the Heart*, depicting the life of Carlos Bulosan.

PINTIG CULTURAL GROUP. This is Chicago's own Filipino American performing arts group. Larry Leopoldo, in the center of the photo, starred in the major role as Carlos Bulosan in the play *America Is In the Heart*. The actors strike a pose at the Fourth Conference of the Filipino American National Historical Society (FANHS) in July 1992, at the Westin Hotel, Chicago.

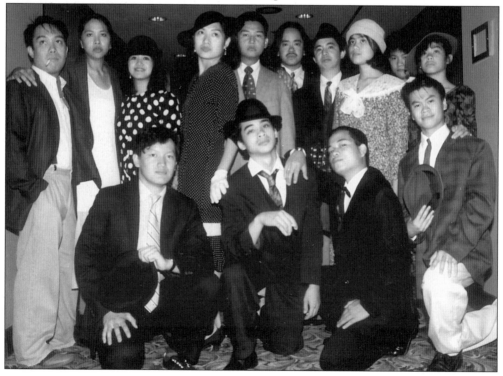

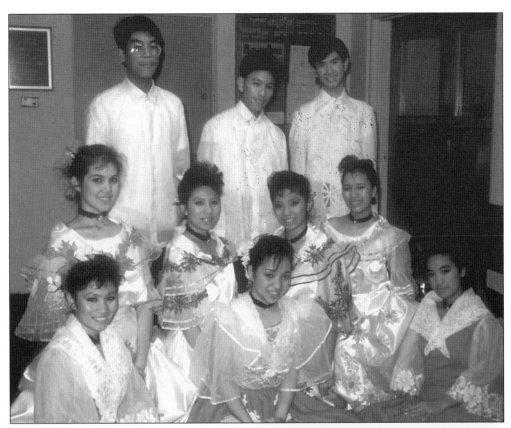

ALMAZAN FILIPINO DANCE TROUPE. In the 1980s, Mr. and Mrs. Almazan encouraged their family of talented daughters and sons to learn the specialized native dances of their native country. The Carol Crisostomo Philippine Dance Company, which originated with the Banzon family, later became known as the Almazan Dance Troupe.

PHILIPPINE ORPHANS CHOIR. Chicago was captivated by the performances of the Philippine Orphans Choir at the Dr. Jose Rizal Center. This photo was taken in April 1992, during a visit from Cebu City, Philippines. The David Livingstone Foundation in Oklahoma sponsored the group's tour.

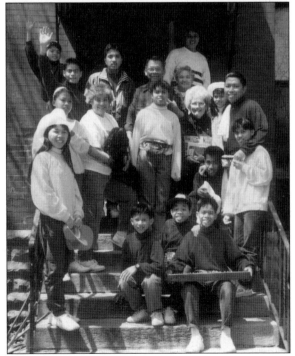

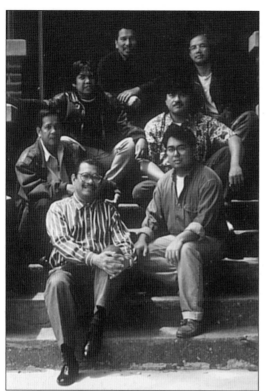

FAVALC. Willi Red Buhay and Buena Silva organized the Filipino American Visual Artists League of Chicago in 1992. Members shown in the picture are Wally R. Buhay, Bueno Silva, Eulalio Silva, Val Navarro, and Eggay Roxas, along with a visiting Filipino artist. (Wally Buhay Photograph Collection.)

FRUIT CARVING. The art of carving is prominent among artists from Paete, Laguna. This photo shows Filipino vegetable carvers in a demonstration exhibit at the first St. Louis Cultural Fair in the 1990s. (Tahanang Buhay Photograph Collection.)

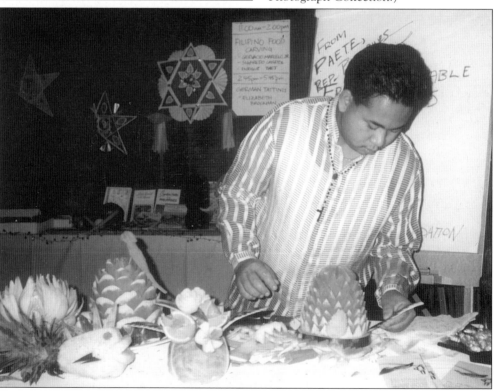

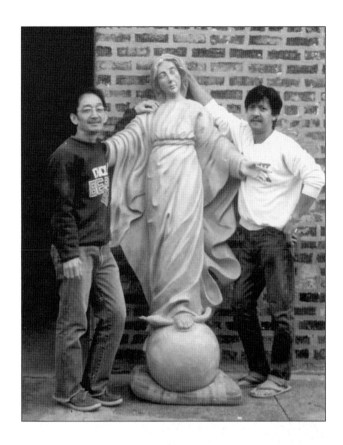

WOOD SCULPTURES. Filipino artists J.R. Cadawas and Ric Bagabaldo from Paete, Laguna, are pictured with a commission piece of sculpture designed for one of Chicago's churches. These noted artists have won distinctive awards for their talents. (Tahanang Buhay Photograph Collection.)

ART WORKSHOP. Sergio "Jun" Rocha, one of Chicago's Filipino artists, is photographed conducting an art class for the youth. (Tahanang Buhay Photograph Collection.)

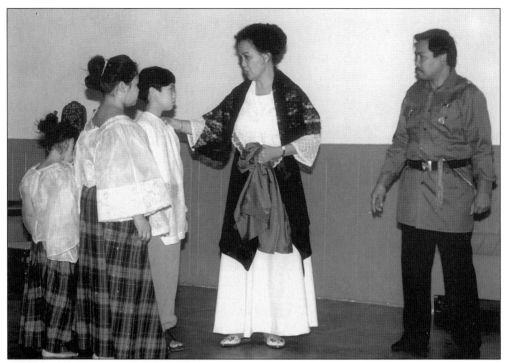

DRAMA. In a play about the national hero, Dr. Jose Rizal, Lorna Rodriguez stars as the mother of Rizal, Dona Teodora Alonzo. (Tahanang Buhay Photograph Collection.)

FASHION. In 1995, "The Evolution of Philippine Wear" from the Tahanang Buhay costume collection was a program sponsored by the University of the Philippines Club at the Harold Washington Library auditorium. Pictured backstage are Boy Llorente and a friend. (Tahanang Buhay Photograph Collection.)

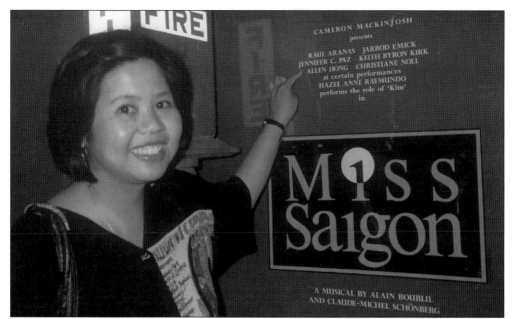

MISS SAIGON. In July 1993, Joan Cordova, Ph.D. Professor in Education from Harvard University, visited Chicago for the Filipino American National Historical Society-Midwest Chapter Conference. She is pictured on a visit to the Auditorium Theatre to meet the *Miss. Saigon* cast of actors. (Alamar Photograph Collection.)

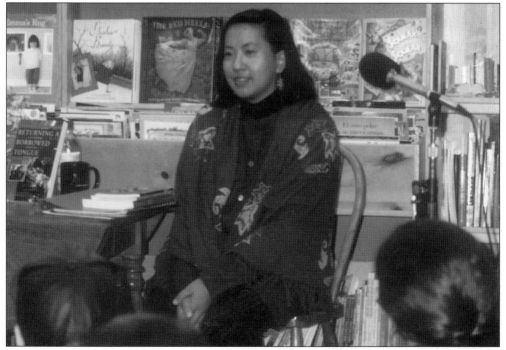

FILIPINA POET. Luisa Aguilar Carino is depicted here performing readings from her literary works in Chicago. Ms. Carino was a scholar at the University of Illinois, Circle Campus. (Tahanang Buhay Photograph Collection.)

DRESS FASHIONS. Filipinas love to dress up. Shown here is Binibining Kalayaan Cristina Madridejos with other beauty queens prepared to parade for the Kalayaan Ball of 1998. (Tahanang Buhay Photograph Collection.)

FACC LIBRARY. In 1996, the Library of the Filipino American Council of Chicago was dedicated. Shown here viewing the collection of Philippine and Filipino American books are Dr. Maria Acierto, Ray Elezagui, and Lourdes Ceballos. (Alamar Photograph Collection.)

HIYAS–KAYAMANANG KAYUMANGGI.
On July 29, 1997, at the Philippine Consul General Bulwagan, international jewelry artist Celia Molano presented "Hiyas" to showcase Philippine fashion in jewelry. The show also featured an interpretative installation by artist Willi R. Buhay on the evolution of the Philippine wear using period costumes.

The Philippine Consulate General cordially invites you to an opening reception of

HIYAS:
KAYAMANANG KAYUMANGGI

featuring select art jewelry of
International Artist Celia Molano
and
Interpretative Period Costume Installation
of Chicago-based Artist Willi Red Buhay
on July 29, 1997, at 6:30 p.m.
Consulate Social Hall
Suite 2100
30 North Michigan, Chicago

Public viewing on
July 30-31, 1997, at 10 a.m. to 4 p.m.

RSVP (312) 332-6458 Rita Herrera

HIYAS. Pictured is Celia Molano, with a descriptive display of the collection. (Alamar Photograph Collection.)

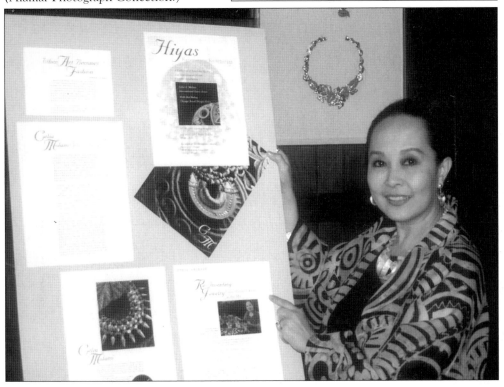

STORYTELLING. At the Filipino American Historical Society of Chicago Program at the North Lakeside Cultural Center in October 1998, Edna Montemayor fascinated members with Philippine stories and legends. She used the drum to enhance her dramatizations. Edna, a nurse at the University of Illinois Hospitals, uses storytelling in her therapy sessions. (Alamar Photograph Collection.)

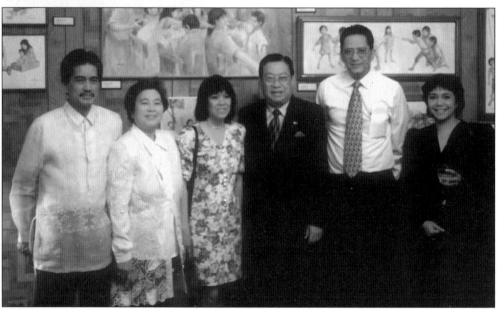

ART EXHIBIT AT THE RIZAL CENTER. The center is a regular venue for cultural events. This art exhibit from Manila depicts the common *taos*, life in paintings. In the photo, from left to right, are Ved Diamante, Thelma Fuentes, Mila Sapnu, Consul General Honorio Cagampan, Rey Sapnu, and Ting Joven. (Tahanang Buhay Photograph Collection.)

KULTURA FILIPINA. Founding Dance Director Mae Lant and the dance troupe are pictured performing at the *Kalayaan* (Philippine Week) celebration at the Daley Center Plaza in June 2000. (Tahanang Buhay Photograph Collection.)

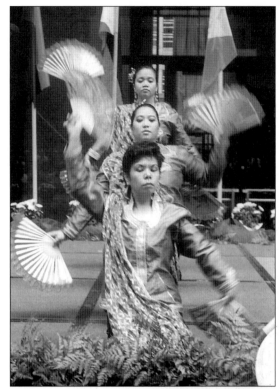

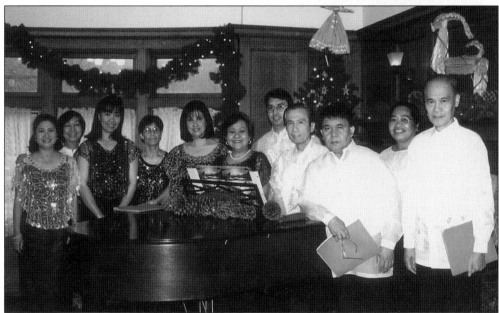

SINAG–TALA CHOIR. Under the direction of Amor Saenz, one of the newest musical groups in the Filipino-American community focuses on religious music. They have also entertained at numerous social events. Members are gathered around the piano at a Christmas program of the Filipino American Historical Society of Chicago at the North Lakeside Cultural Center at 6219 North Sheridan Road, Chicago. (Alamar Photograph Collection.)

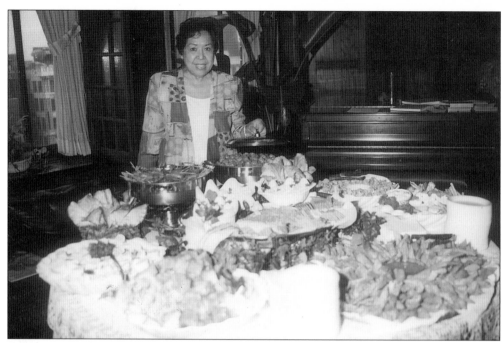

PHILIPPINE CUISINE. Filipina culinary expert and caterer Norma Manankil is shown before a display of her Philippine specialties at a reception at the Philippine Consulate. (Tahanang Buhay Photograph Collection.)

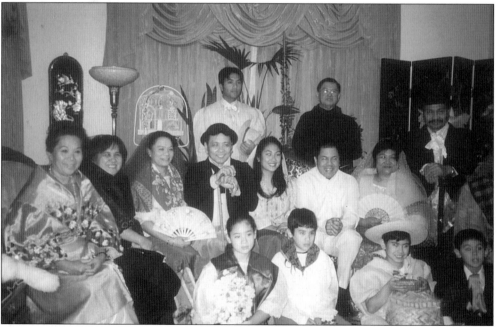

PANTOMINA. The Filipino American group, the Philippine Professionals Association (PPA), performed *Pantomina* in 1999. The drama focuses on the period of the 1890s, depicting age-old Filipino traditions, folk costumes, music, and humor. The president of PPA was Dr. Romeo Muñoz. (Tahanang Buhay Photograph Collection.)

Four

SPORTS

Filipinos excel in various sports. From the 1930s to the 1950s, Chicago's *Pinoys* participated in competitive sports such as softball, track and field, golf, bowling, tennis, and table tennis during Intercity Athletic Meets between Chicago, Detroit, New York, and Washington, D.C. On Sundays during the summer, many families spent the day at picnics in Grant Park at Balboa Drive during the Filipino softball games. From the 1950s to the 1970s, the Filipino American Bowling League was one of the largest sports activities in the community. Under the direction of Florentino Ravelo, many bowlers participated in major tournaments and won prizes in Chicago and many other cities.

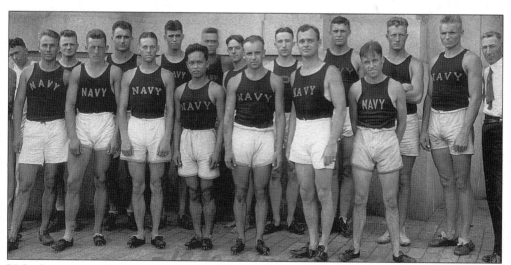

U.S. OLYMPIAN. This photo shows Salvador (Sal Cepeda) in 1920, when he was selected to represent the United States as a member of the Navy team of athletes at the international Olympic games in Brussels, Belgium. He was a participant in the track and field competition. (Cepeda Photograph Collection.)

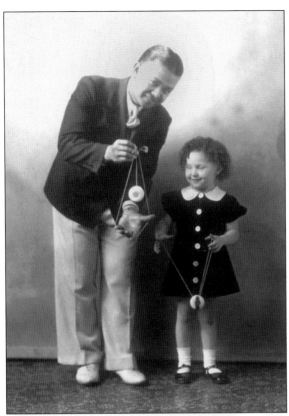

YO-YO STAGE SHOW. In 1938, Albert Viernes appeared in a stage show in Sandusky, Ohio, with a young girl resembling Shirley Temple. Filipino yo-yo experts toured around the country demonstrating yo-yo tricks in small towns at stores, theaters, and parties.

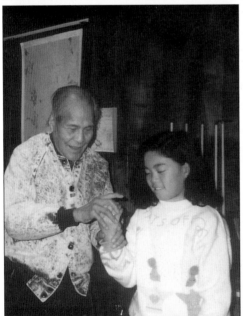

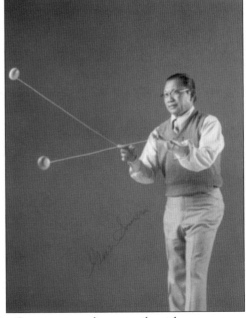

YO-YO MASTERS. Frederico "Fred" Urian and Gus Somera were also versatile with many yo-yo tricks. Other *Pinoys* from Chicago who fascinated audiences both young and old were Selmo Saladino and Tommy Lima. Somera performed at the Taste of Chicago stage for several years.

INTER-CITY ATHLETIC MEET IN CHICAGO. In 1952, a big Intercity Athletic Meet of *Pinoy* athletic stars from Chicago, Detroit, New York, and Washington, D.C. participated in many sporting events. At Grant Park, with a display of awards, pictured from left to right, were officials Francis Solis, Mr. Mamaril, Senator Cabili, Minister Ambassador Narciso Ramos, Florentino Ravelo, and Jose Leonidas. (Ravelo Photograph Collection.)

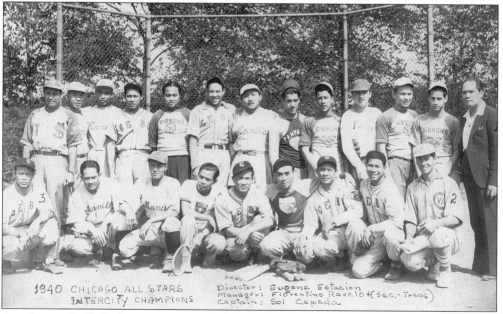

1940 CHICAGO ALL STARS INTERCITY CHAMPIONS

Director: Eugene Estacion
Manager: Florentino Ravelo +(sec.-Treas)
Captain: Sol Cepeda

ALL STARS. Softball players representing the best of their respective Chicago teams formed the All Stars team. Eugene Estacion (in the suit) was overall director of the athletic program. Florentino Ravelo was manager. (Ravelo Photograph Collection.)

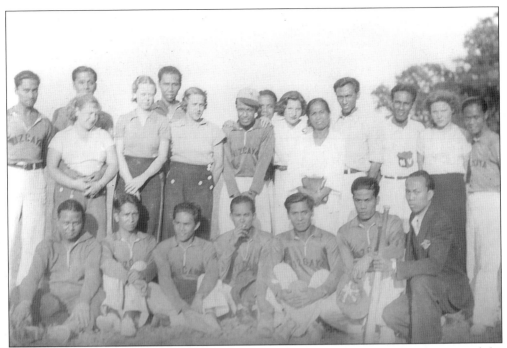

SOFTBALL TEAM. Pictured here is the Nueva Vizcaya Association softball team, one of the many competing teams from Chicago. (Ravelo Photograph Collection.)

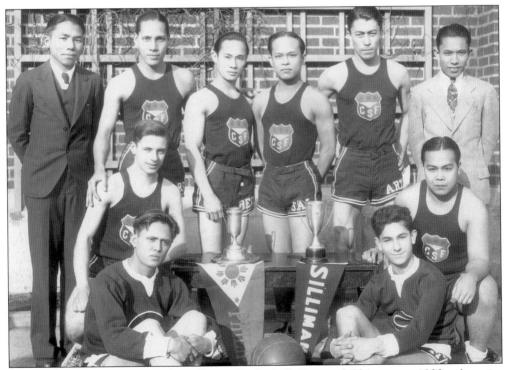

BASKETBALL TEAM. This is the Silliman Basketball Team of Chicago, *c.* 1920s. A major organizer of the team was Sal Cepeda. (Cepeda Photograph Collection.)

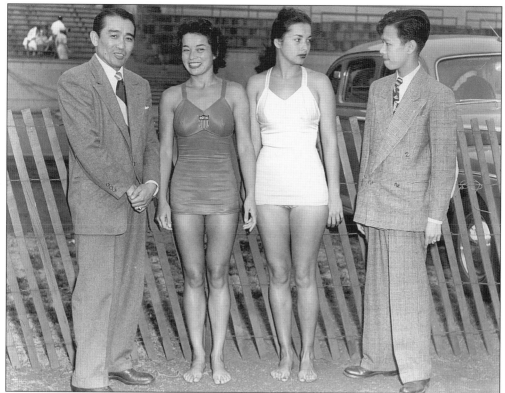

U.S. OLYMPIAN GOLD MEDALIST. Resti Paulo greets Vicki Draves, champion swimmer and diver. She was the first Filipino American to capture gold medals on a U.S. Olympic Team at the 1948 World Olympics. She was on tour, starring in Buster Crabbe's 1949 edition of the *Aqua Parade* at the Chicago Arena, McClurg Court, between Erie and Ontario. (Paulo Photograph Collection.)

FILIPINO FAR-EASTERN BOWLING LEAGUE. The only Filipino American Bowling League was later known as the Filipino American Bowling League of Chicago. It embraced a diversity of bowlers, not just *Pinoys*. There was a close camaraderie among the players. League Secretary-Treasurer Florentino Ravelo organized the players to compete in tournaments in Illinois and other states. (Ravelo Photograph Collection.)

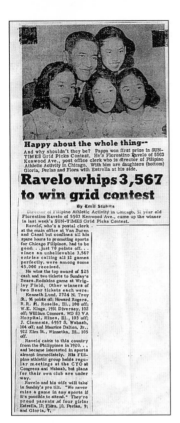

GRID CONTEST. Florentino Ravelo was versatile in his interest in sports, actively and passively. Here he won an award—$25 and two tickets to the Bears-Redskins football game—in the *Sun-Times* Grid Contest in November 1948.

Happy about the whole thing—
And why shouldn't they be? Pappa won first prize in SUN-TIMES Grid Picks Contest. He's Florentino Ravelo of 5503 Kenwood Ave., post office clerk who is director of Filipino Athletic Activity in Chicago. With him are daughters (bottom) Gloria, Perlas and Flora with Estrella at his side.

Ravelo whips 3,567 to win grid contest

By Emil Stubits

Director of Filipino Athletic Activity in Chicago, 51 year old Florentino Ravelo of 5503 Kenwood Ave., came up the winner in last week's SUN-TIMES Grid Picks Contest.

Ravelo, who's a postal clerk at the main office at Van Buren and Canal but confines all his spare hours to promoting sports for Chicago Filipinos, had to be good. . .just 70 points off. . .since an unbelievable 3,567 entries calling all 12 games perfectly, were among some 45,000 received.

He wins the top award of $25 cash and two tickets to Sunday's Bears-Redskins game at Wrigley Field. Other winners of two Bear tickets each were: Kenneth Lund, 2724 N. Troy St., 96 points off; Howard Rogers, R.R. #1, Roselle, Ill., 100 off; W.E. Kluge, 1931 Diversey, 102 off; William Connors, WD 83 VA Hospital, Hines, Ill., 103 off; J. Clemens, 6957 S. Wabash, 104 off; and Maurice Dalton, Jr., 922 Elm St., Winnetka, Ill., 105 off.

Ravelo came to this country from the Philippines in 1920. . . and became interested in sports almost immediately. His Filipino athletic group holds regular meetings at the CYO at Congress and Wabash, but plans for their own club are under way.

Ravelo and his wife will take in Sunday's pro tilt. "We never miss a game in any sports if it's possible to attend." They're proud parents of four girls: Estrella, 12; Flora, 10, Perlas, 9; and Gloria, 7.

OUTDOOR ACTIVITY. Participation in an endurance activity are some youth at a City of Chicago Asian American Youth Leadership Conference weekend program. Coordinator of the program was Elsie Sy-Niebar, Assistant to the Commissioner of the Chicago Department of Human Services. (Tahanang Buhay Photograph Collection.)

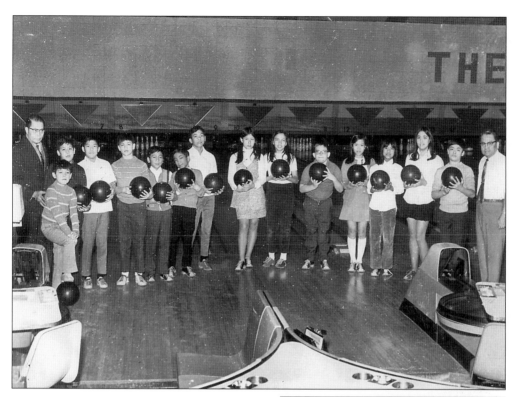

YOUNG BOWLERS. Carmelito Llapitan organized the Junior Philippine American Bowling League for children ranging in ages from 6 to 15 years. Pictured in a tournament held in March 1970, from left to right, are Amador Dominquez, Carme's assistant, Paul Rojas Jr., David Ordinario, Willie Urian, Victor White, Alex Jaime, John Corpuz, Rudy Urian, Tanya Rojas, Anita Gaudia, Jose Garcia, Jeanette Corpuz, Tessie Urian, Cindy Ordinario, and Richard White. All the children are second or third generation, American-born. Donated trophies were awarded to the players. (Photograph by Cedric Esta.)

MIGHTY MITE. Before his retirement to Highland Park, Illinois, Felicisimo Ampon (1920–1997) made his mark on the international tennis scene. Among his accomplishments, he was a member of the Philippine team to the Davis Cup from 1939 to 1968; he participated in the 1940 Far Eastern Athletic Games; the 1948 All-England Plate in Wimbledon, England; and triumphed over American Tom Brown in the 1950 Pan-American Championships in Mexico. (Tahanang Buhay Photograph Collection.)

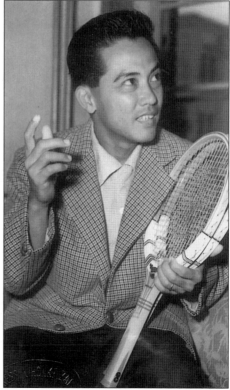

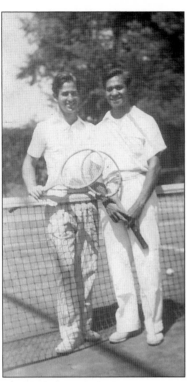

TENNIS. Bobby Riggs, the first United States Wimbledon champion, visited Chicago at the Edgewater Beach Hotel Tennis Club to demonstrate and instruct. He is pictured here with Florentino "Tino" Ravelo. (Ravelo Photograph Collection.)

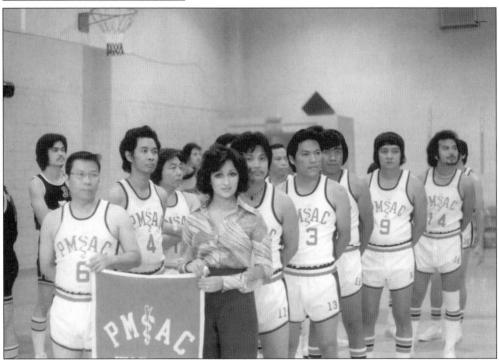

BASKETBALL TEAM OF THE 1960S. In the picture are members of the Philippine Medical Association of Chicago team. Avid supporters were the PMAC auxiliary members. (Llapitan Photograph Collection.)

SOCCER. This is Hanna Auza, showing her skills in a high school soccer event in Downers Grove, Illinois. (Auza Photograph Collection.)

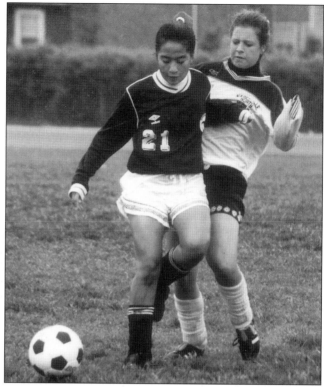

CHICAGO ATHLETIC STARS. Pictured with Philippine Consul Leopoldo Ruiz (center) is the 1947-48 Athletes of the Filipino National Council of Chicago, chosen to represent Chicago in the Filipino Inter-City Athletic Federation of America Inter-City Athletic Meet in Washington, D.C., from August 31 to September 6, 1948.

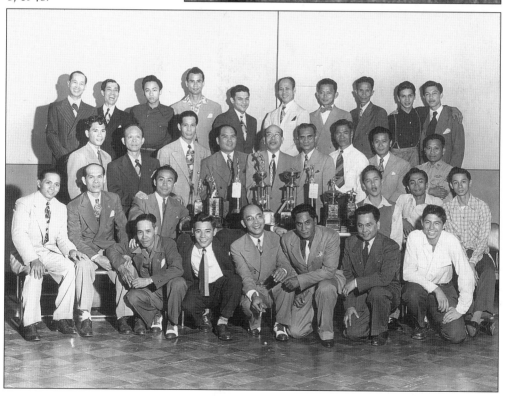

65

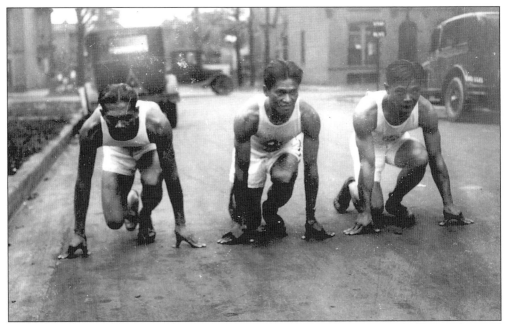

TRACK STARS. On a local West Side street, Vincent Ilustre and Tino Ravelo (first and second positions) are warming up for a race. (Ravelo Photograph Collection.)

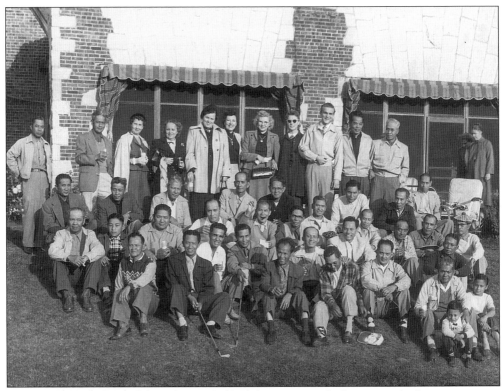

GOLF CLUB. Members of the Filipino Golf Club are pictured after a round of competition in the 1950s. (Ravelo Photograph Collection.)

Five
RELIGION

ABOUT THE COVER In January 1929, to propagate the cause of Catholic religion among the Filipinos, some Filipino students and professionals founded the Filipino Gibbons Society. Rev. John E. Burke, C.S.P., Pastor of Old St. Mary's Church at 1122 South Wabash Avenue, Chicago, served as the first Spiritual Director and Moderator. Paulist Fathers have served as Spiritual Directors. Father Leo Lyden, C.S.P., had the longest term—20 years. Ten years later, the name was changed to the Catholic Filipino Guild. Though Catholic Filipino American families worship at their neighborhood churches, they joined together for many years for activities and spiritual programs under the Guild. The Guild still exists under the leadership of Mrs. Julie Dumo, who has been president for 38 years.

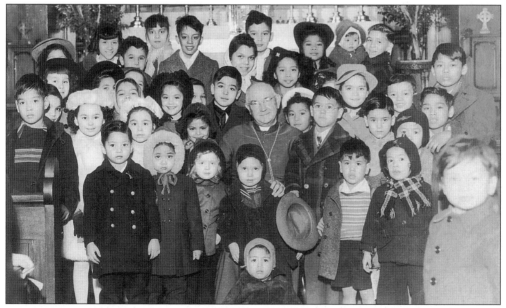

CARDINAL STRITCH. This photo, taken in 1946, was printed in the local Catholic newspaper with the following caption: "The youngest members of Chicago's Filipino colony gathered around Archbishop Samuel A. Stritch when His Excellency presided recently at the annual Mass of the Filipino Catholic Guild in old St. Mary's Church. Headquarters of the guild members and their families have been established in the Catholic Youth Organization building at 31 E. Congress St."

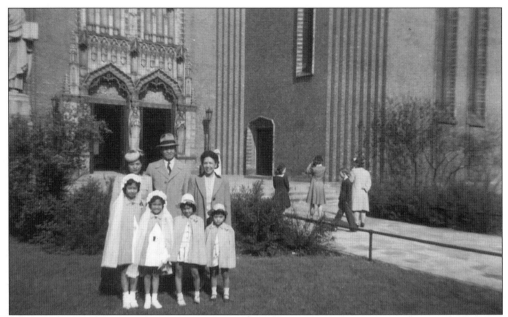

FIRST COMMUNION. Taken in the 1940s, this photo shows the Florentino Ravelo family with Julita Sotejo during the First Communion of Estrella and Flora at St. Thomas the Apostle Catholic Church, 5472 South Kimbark Avenue, Chicago. All the children's Easter Sunday outfits were designed and made by their mother, Ambrosia.

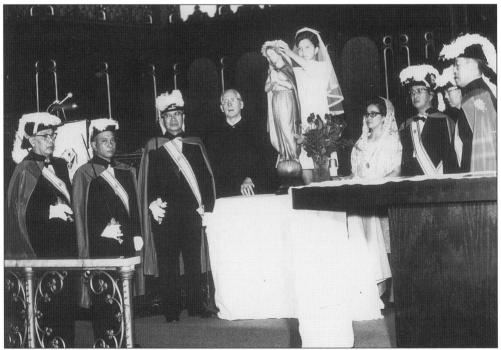

KNIGHTS OF COLOMBUS. This photo shows a May crowning ceremony at Old St. Mary's Church, 11th Street and Wabash Avenue. Leander de la Cruz is among the Knights pictured. (Photograph by Cedric S. Esta.)

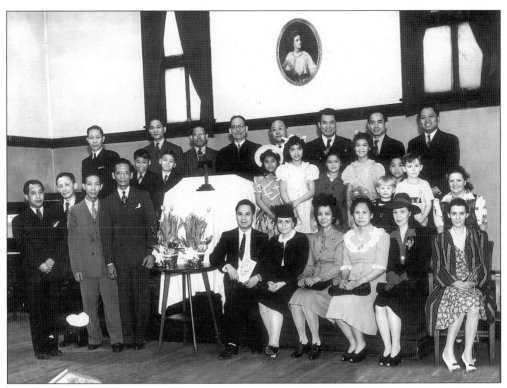

FILIPINO COMMUNITY CHURCH.
The occasion here is the Reception of Members on Easter Sunday in April 1943. The Filipino Community Church is an interdenominational community located at 125 West Chestnut Street, Chicago. The minister was Rev. Bienvenido O. Tolentino. (Alamar Photograph Collection.)

THANKSGIVING SERVICE. On November 26, 1942, a Thanksgiving service was held in honor of the Filipinos in the U.S. Armed Forces from the Chicago area and vicinity at the Filipino Community Center at 640 North State Street, Chicago. The written program listed 400 names (there should be around 600) in the Honor Roll. (Alamar Photograph Collection.)

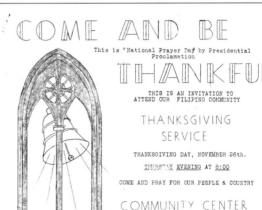

COME AND BE

This is "National Prayer Day" by Presidential Proclamation

THANKFUL

THIS IS AN INVITATION TO
ATTEND OUR FILIPINO COMMUNITY

THANKSGIVING
SERVICE

THANKSGIVING DAY, NOVEMBER 26th.
THURSDAY EVENING AT 8:00

COME AND PRAY FOR OUR PEOPLE & COUNTRY

COMMUNITY CENTER
640 NORTH STATE STREET, CHICAGO, ILL.

- EVERYBODY WELCOME -

TO
DEDICATE
FILIFINO SERVICE FLAG
IN HONOR
OF FILIPINOS IN THE U.S.
ARMED FORCES
FROM THE CHICAGO AREA AND
VICINITY

☆

400

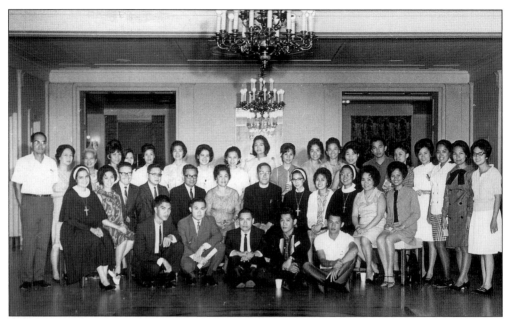

FISCA. Doctors, nurses, and other professionals in the United States under the Exchange Program organized the Filipino Spiritual Community Action (FISCA) March 14, 1957. Among those pictured are Sister Angie Villanueva, Loreta and Dominick Fortunato, Tony Sebastian, Bienvenido Parong, Ronnie Somera, Vicente Ereneta, Conrado Manankil, and Bong Garcia. (Photograph by Cedric S. Esta, Llapitan Photograph Collection.)

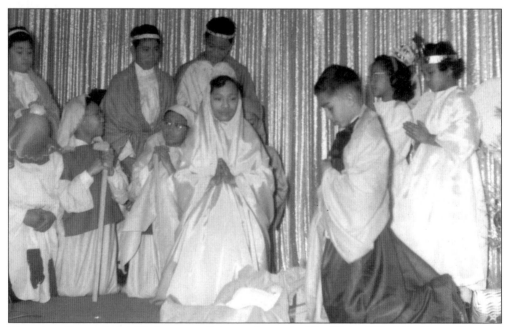

NATIVITY SCENE. It is a Christmas tradition to dramatize The "Belen" Nativity Scene. Pictured here is a group of young Nueva Vizcaya Association members in a re-enactment of the birth of Jesus at the annual Christmas party in December 1960. Christina Tamani and Brad Womack portrayed Mary and Joseph.

THE BLESSED VIRGIN OF ANTIPOLO.
Ching Molano and Paula Ereneta are
photographed at the visitation of the
Blessed Virgin of Antipolo, which was
enshrined at the first Filipino chapel of
the Immaculate Concepcion Catholic
Cathedral in Washington, D.C.
(Tahanang Buhay Photograph
Collection.)

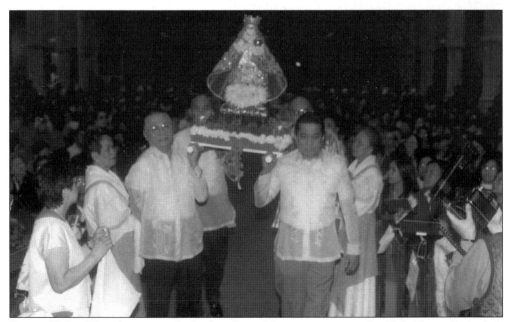

SANTA NIÑO. This photo records the first Santo Niño procession at the Holy Name Cathedral.
(Tahanang Buhay Photograph Collection.)

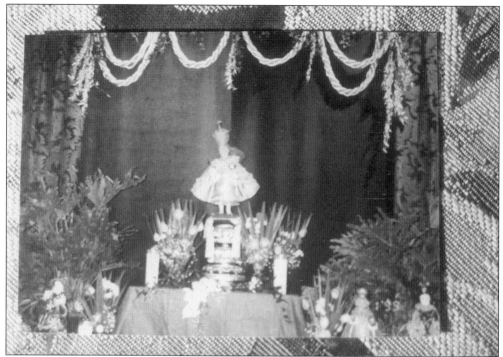

SANTA NIÑO. In 1998, the first Santo Nino Festival took place at the Dr. Jose Rizal Center. (Photograph by Alamar, Tahanang Buhay Photograph Collection.)

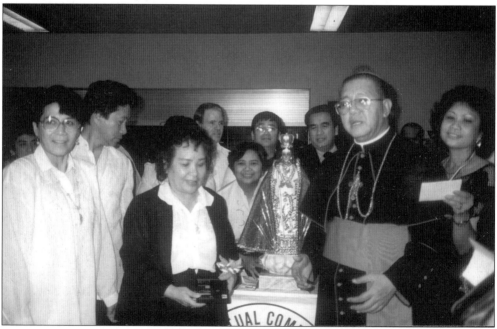

CARDINAL SIN VISITS CHICAGO. In 1987, a Mass was held at Holy Name Cathedral officiated by Cardinal Sin. Pictured at the reception were, from left to right, Virginia Jaramilla, Paula Ereneta, Dr. Beltran, and Cardinal Sin.

SPECIAL MESSAGE. His Eminence Joseph Cardinal Bernardin celebrated a Mass for the Filipino-American community on Saturday, September 7, 1985, at St. Benedict's Church, 2215 West Irving Park Road, Chicago.

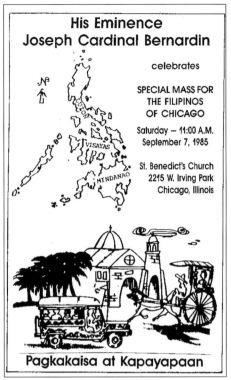

His Eminence Joseph Cardinal Bernardin

celebrates

SPECIAL MASS FOR THE FILIPINOS OF CHICAGO

Saturday — 11:00 A.M. September 7, 1985

St. Benedict's Church 2215 W. Irving Park Chicago, Illinois

Pagkakaisa at Kapayapaan

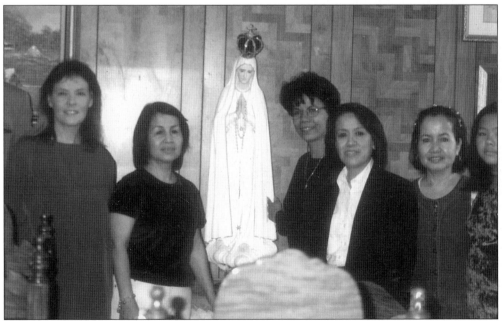

PILGRIM VIRGIN OF FATIMA. This event was the religious tradition of honoring the pilgrim Virgin of Fatima. It took place in May 1999, at the Dr. Jose Rizal Center, 1332 West Irving Park Road, Chicago. Shown are Elizabeth Masancay, Mila Sapnu (First lady of the Filipino American Council of Chicago), and other devotees. (Tahanang Buhay Photograph Collection.)

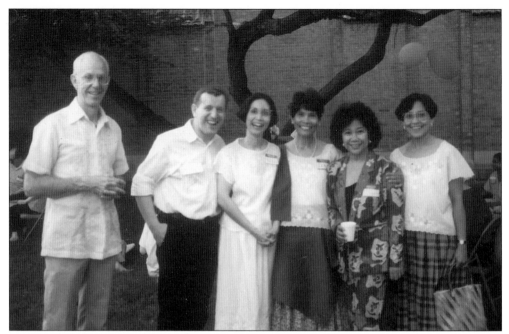

MISSIONARY WORK. Zenaida Corpuz devoted a year of missionary work with the Casa Minstral Mission in 1991. She provided nursing care and training to natives of the *Pincoya* community in Santiago, Chile, and also in the Dominican Republic. Pictured at her *despidida* farewell gathering at St. Thomas the Apostle Church are, from left to right, Jim Burris, unidentified, Tina Garcia, Zeny Corpuz, Josie Disterholtz, and Juanita Burris.

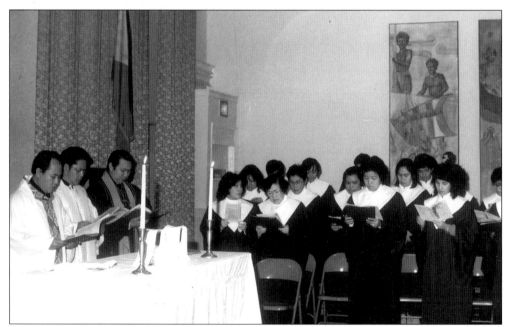

ECUMENICAL SERVICE. November 1983 marks an Ecumenical service led by Rev. Vic Esclamado and other clergy at the Dr. Jose Rizal Center. Members of the various religious groups in the Filipino-American community attended it.

Six
BUSINESS AND PROFESSIONS

In the 1920s, the largest number of Filipinos came to Chicago as professionals to pursue further studies as *pensionados*. Many of them remained in the United States. They are among the Filipino Americans who have contributed their talents and endeavors to the growth and development of the American business and professional profile during the last century.

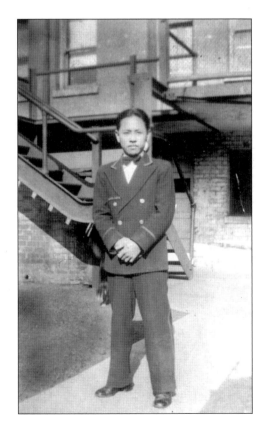

DEL PRADO HOTEL. After World War II, U.S. Army veteran Fernando Manat was employed as a hotel bellhop at the Del Prado Hotel at 5300 South Hyde Park Boulevard in Hyde Park. Many *Pinoys* were employed in hotels as bellhops, cooks, and other roles.

RAILROAD. Railroad work was among some of the most secure jobs for *Pinoys*. New York Central's Scenic Water Level Route was one of the many routes assigned to *Pinoys*. They worked mainly as waiters. During its heyday, Chicago, as the hub of the railroad industry, was home and often the layover destination for workers and passengers.

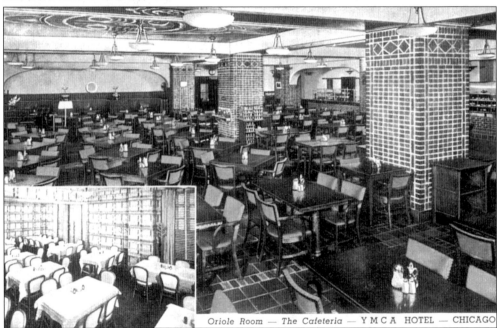

Oriole Room — The Cafeteria — Y M C A HOTEL — CHICAGO

YMCA HOTEL. Men, women, and families could get accommodations here from $1–2 per day. *Pinoys* lived and worked in this large YMCA Hotel at 826 South Wabash Avenue. Mr. Serra was among the residents. Workers included Manuel Dumo, who met his future wife, Julie, here.

OUTSTANDING FILIPINO ENGINEER. Benito Piit, a native of Cagayan, Misamis, is considered one of the most outstanding Filipinos of Chicago. In the 1920s, he came to Chicago as a self-supporting student. His engineering degree from the University of Illinois opened the doors to a productive career. He contributed much to the beautification of Chicago and the building of bridges and highways across the state of Illinois. His projects included the Baha'i Temple, the Conrad Hilton Hotel, and the Palmer House annex.

BARBER. On August 1, 1948, Louis "Louie" Cortez, after returning from U.S. Army service in World War II, opened up his own barbershop on East 55th Street in Hyde Park. He remained in business until the 1990s. Among other Chicago barbers were Mr. Karganilla and Mr. Madriaga. (Alamar Photograph Collection.)

Outstanding Filipino enginee

Unfortunately, the annual search for outstanding Filipinos in the United States was not launched during the his me.

If it did came to pass, the late Benito Piit, native of erstwhile Cagayan, Misamis (now Cagavan de Oro City, Misamis Oriental), could have been asily one among the first to be cited for uch distinction and honor.

This was voiced by Tony Breviescas, 0, native of Surigao, other ilipino oldtimers who remembered Piit as an engineer whose outfit ontributed much to the beautification f Chicago and building of bridges and ighways across the state of Illinois.

Piit died of flu complications in 1953, hortly after a stint as project engineer n the construction of the Baha'i house f worship at Wilmette, Illinois.

The Baha'i Temple was listed on May 23, 1978, in the U.S. national egister of historic places as "one of the nation's cultural resources worthy of preservation."

A civil engineering graduate at Illinois University of Urbana, Piit first worked with Holibard Roches Engineering Company which built the Conrad Hilton Hotel, the first of Hilton's world-wide chain, then known as Stevens hotel.

After the construction was completed, Breviescas said Piit was assigned to build the Chicago temple, another city landmark, and the Palmer House annex.

At this point, Piit and his boss formed their own outfit called Shapiro Engineering Company which was extensively involved in the State's infrastructure development program.

BENITO PIIT

Breviescas provided him with financial support through college.

For his part, Breviescas was employed as clerk in the U.S. Postal Service for 48 years and was presented the Federal Service Award from Washington, D.C., when he retired in 1969.

In addition, he received an honorable gold plated service award in recognition of 48 years of continued service as a federal government employe.

Breviescas has never seen the Philippines since he set foot on American soil in 1919. He married and Irish lass in 1925 but divorced her two years later because she could not bear any child.

When World War II broke out in the Pacific, Breviescas answered the call

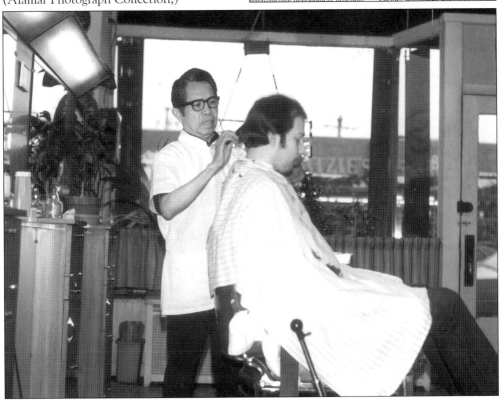

COOK COUNTY HOSPITAL. Among the first Filipino nurses in the 1930s at Cook County Hospital were Julio Lorenzana and Mrs. Venancia Samonte. Since the immigration law passed in the 1960s, hundreds of Filipino nurses have worked at Cook County Hospital and many other hospitals throughout the city. (Alamar Photograph Collection.)

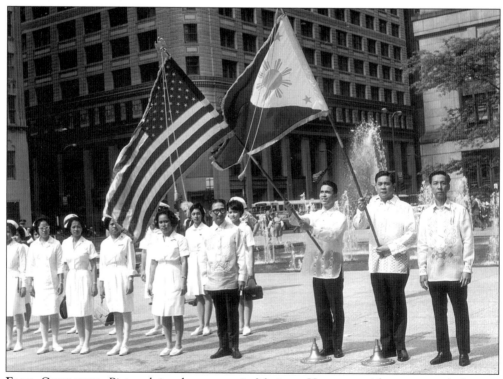

FLAG CEREMONY. Pictured in the center is Mariano Hermoso with nurses and doctors, participating in a Philippine Week celebration in the 1970s at Daley Plaza. (Mr. and Mrs. Mariano Hermoso Photograph Collection.)

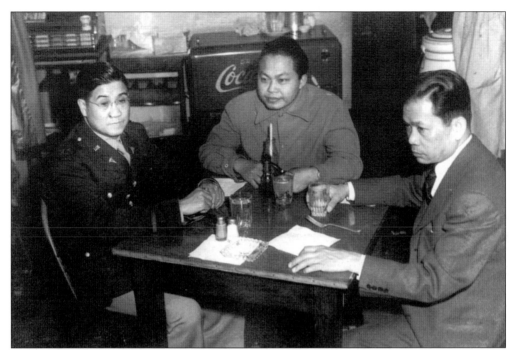

VISIT WITH FRIENDS. In the early 1940s, during World War II, Dr. Fernando Aguila is pictured in uniform visiting with friends. Dr. Feliciano Hicaro is on the right. (Frances Hicaro Photograph Collection.)

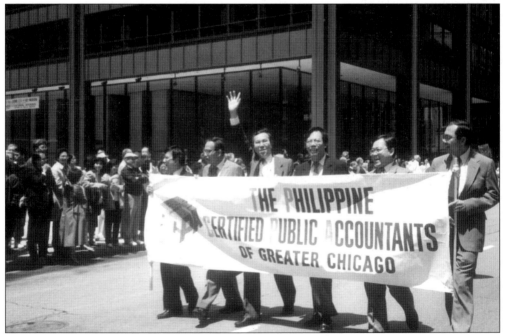

CERTIFIED PUBLIC ACCOUNTANTS. Many CPA professionals were among the first immigrants to the United States after the passage of the Immigration Act of 1965. Some are pictured here during a Philippine Week parade on Dearborn Street.

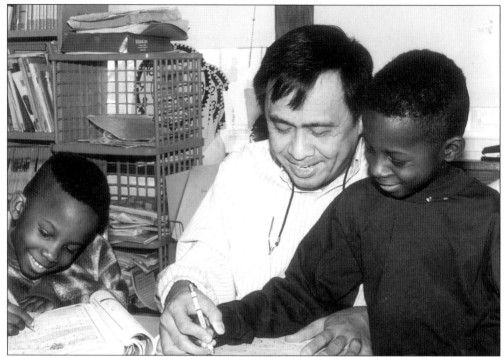

SPECIAL EDUCATION PROFESSIONAL. Rey de la Cruz, Ph.D. is a special education professional and playwright author. Here, he is photographed giving special instructions in handwriting lessons to his students. (Rey de la Cruz Photograph Collection.)

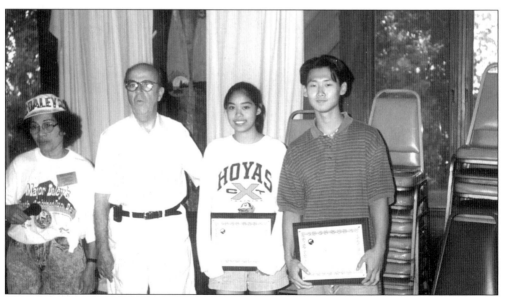

CITY OF CHICAGO HUMAN SERVICES YOUTH WORKSHOP. This photo was taken in September 1995, at an Asian American Youth Leadership Workshop Conference. The weekend workshop was held at an outdoor camp facility. Elsie Sy-Niebar, Assistant to the Commissioner of the City of Chicago Department of Human Services, and Daniel Alvarez Sr., Commissioner, are presenting awards to two participants. (Alamar Photograph Collection.)

HERMOSA TRAVEL. Mariano Hermosa and his wife, Fe, two of the most successful travel consultants, are pictured in their office, "Cruise 'n Tours" on North Racine Avenue in Chicago. The picture was taken in 1994. (Alamar Photograph Collection.)

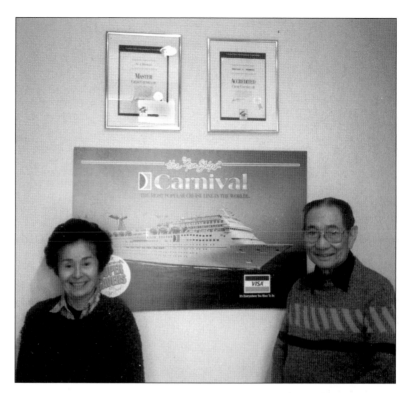

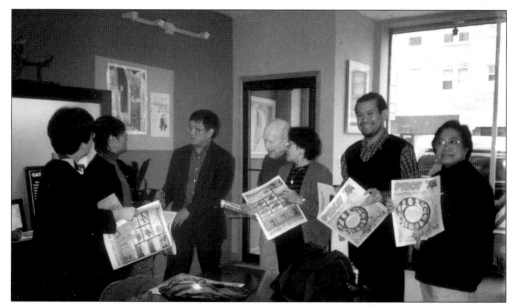

JOURNALISM. Visitors to the Filipino American Historical Society of Chicago Museum review copies of the newest Filipino newspaper publication, *Pinoy*. From left to right are Emer Kallas, Zenaida Corpuz, Mariano "Anong" Santos (*Pinoy* editor and publisher), Roy Kallas, Juanita Burris, Willi Buhay, and Edna Montemayor. (Alamar Photograph Collection.)

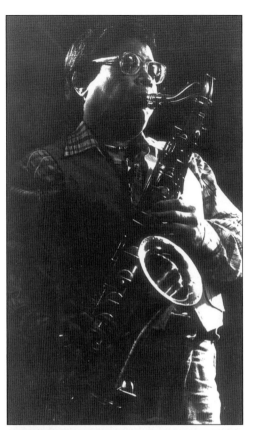

JAZZ MUSICIAN TOMMY PONCE. He is a second-generation *Pinoy* who became very popular in the Chicago jazz scene during the 1950s. He played the sax, bass fiddle, and piano. He played with many celebrated jazz artists in the nightclub circuit. He also had his own trio and dance band. His brother, Don, was also an accomplished musician.

MANILA-MANILA RESTAURANT. Peggy Monserrat, a staff member of the Philippine Consulate, is pictured at the booth of the Manila-Manila Restaurant at the first Asian American Festival in the early 1990s, held at Navy Pier.

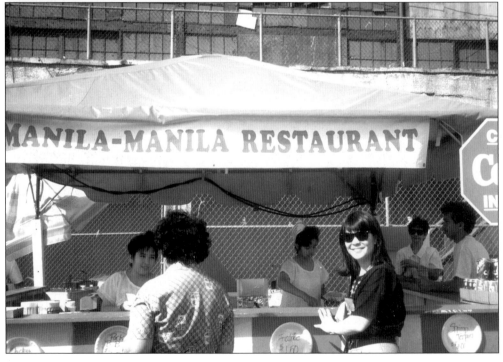

Seven

RIZAL

The first Filipinos who came to Chicago were born during the period of Dr. Jose Rizal's life in the Philippines. While in Chicago, the Filipinos were cognizant of the political issues of the period of 1898 to the early 1900s in their homeland. They organized clubs to socialize and also to debate current issues such as independence from the United States. The highlight of each year was the celebration of Rizal Day, commemorating the death of Dr. Jose P. Rizal on December 30. This annual, formal occasion was held in the most beautiful hotel banquet rooms of Chicago. Today, the Filipino American Community commemorates the birth and death of the national hero every June and December.

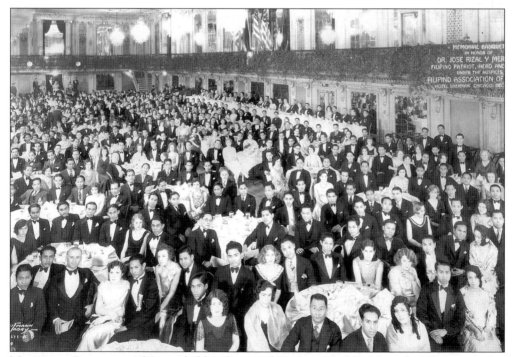

MEMORIAL BANQUET. This was held in honor of Dr. Jose Rizal Y. Mercado, Filipino patriot, hero, and martyr under the auspices of the Filipino Association of Chicago at the Hotel Sherman in Chicago on December 28, 1930.

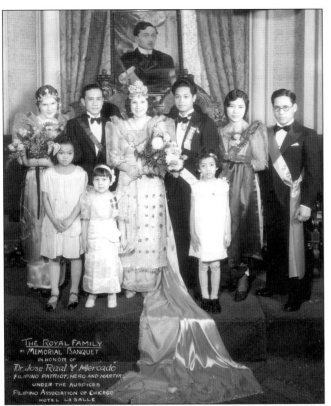

THE ROYAL FAMILY
AT MEMORIAL BANQUET
IN HONOR OF
Dr. Jose Rizal Y Mercado
FILIPINO PATRIOT, HERO AND MARTYR
UNDER THE AUSPICES
FILIPINO ASSOCIATION OF CHICAGO
HOTEL LA SALLE

THE ROYAL FAMILY. This memorial banquet was held in honor of Dr. Jose Rizal Y. Mercado, Filipino patriot, hero, and martyr, under the auspices of the Filipino Association of Chicago at the Hotel La Salle on December 27, 1931. (Burke & Koretke Photograph, Chicago.)

RIZAL DAY QUEEN 1935-36. Pictured in the Queen's Court, from left to right, are Roy Boliquat and Miss Philippines, Susan Cichonski (later Mrs. Mariano Vitor); Mr. Reyes and Queen Margie; and Miss America, Vida. "The Filipinos of Chicago," one of the groups holding a Rizal Day that year, dined, and danced at the Palmer House. (Vitor Photograph Collection.)

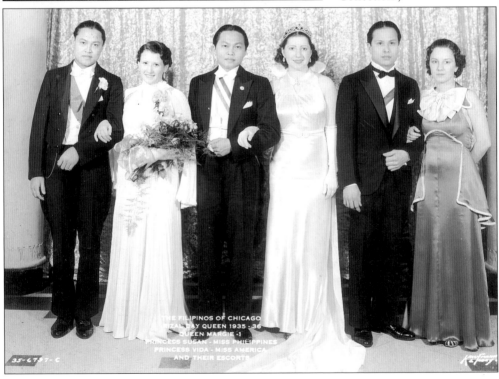

THE FILIPINOS OF CHICAGO
RIZAL DAY QUEEN 1935-36
QUEEN MARGIE -1
PRINCESS SUSAN - MISS PHILIPPINES
PRINCESS VIDA - MISS AMERICA
AND THEIR ESCORTS

35-6797-C

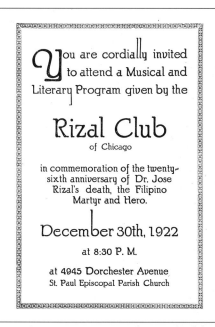

You are cordially invited to attend a Musical and Literary Program given by the

Rizal Club
of Chicago

in commemoration of the twenty-sixth anniversary of Dr. Jose Rizal's death, the Filipino Martyr and Hero.

December 30th, 1922

at 8:30 P. M.

at 4945 Dorchester Avenue
St. Paul Episcopal Parish Church

The Rizal Club
OF CHICAGO

CORDIALLY INVITES YOU TO A

MUSICAL
LITERARY PROGRAM

GIVEN IN

COMMEMORATION OF THE THIRTIETH
ANNIVERSARY OF THE

DEATH OF

Dr. Jose Rizal

PLACE:- SECOND BAPTIST CHURCH AUDITORIUM
TIME:- THURSDAY, DECEMBER 30, 1926
AT 8 P. M.

RIZAL CLUB PROGRAMS. The Rizal Club events date back as early as 1922 and 1926. Two of the programs pictured here indicate that they took place in churches on the South Side of Chicago in Hyde Park. (Ravelo Collection.)

The Rizal Club
OF CHICAGO

cordially invites you to their

DANCE

given in honor of the retiring officers

on the evening of May 22, 1926

8:00 to 12:00

ALL SOULS CHURCH

BLACKSTONE AND 66th PL.

RIZAL DAY PROGRAM

Toastmaster — C. Manat

1. Selection The Concert Trio
2. Greetings Mr. T. P. Caro
3. Steel Guitar Solos Mr. M. Domingo
 Nevin; The Rosary
 Mighty Lak a Rose
4. Speech Mr. F. Alayu
5. Vocal Solo Miss Ethel Philips
 Flute Obligato Mr. M. Domingo
6. Violin Solo Mr. D. Kabayao
7. "The Meaning of Rizal's Life" Mr. V. Verano
8. Song Glee Club
 Messrs. Alayu, Ravelo, Afalla, Caro, Dumelod, Manat
9. Speech Captain George Frederick Unmach,
 Captain in the U. S. Army, Chicago Headquarters
10. Selection Concert Trio

Philipine National Anthem

Star Spangled Banner

A MERRY CHRISTMAS & A HAPPY NEW YEAR

THE RIZAL CLUB, May 22, 1926. Shown here is the evening's program for a special event.

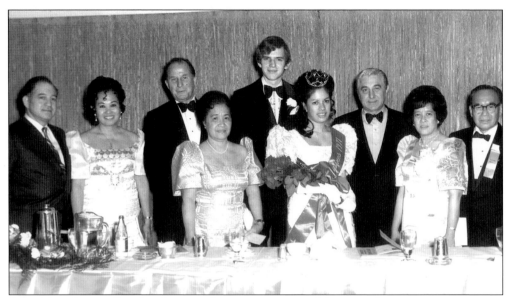

RIZAL DAY QUEEN. Rosalita Cruz was the reigning queen of this annual commemorative event. Pictured, left to right, are Sidney Altman, guest Ann Llapitan, escort Carl Flowers, Rosalita Cruz, Alderman Roman Pucinski, and Julie and Rosauro Cruz. (Gonzales-Cruz Photograph Collection.)

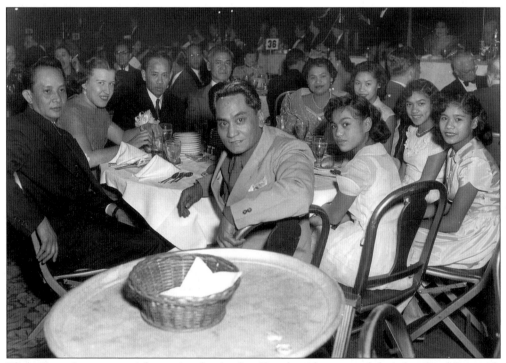

FIRST TIME. It was a special occasion for the four Ravelo girls to attend their first Rizal Day with their parents. This event was held at the Hotel Sherman in December 1952. Clockwise, from left to right, are Mr. and Mrs. Pete (Ruth) Galinato, Fred Manat, Mr. and Mrs. Florentino (Ambrosia) Ravelo, Estrella, Pearl, Flora, Gloria, and Tim Ravelo. (Galinato Photograph Collection.)

GRAND OPENING. Pictured is the cover of the souvenir program of the grand opening of the Dr. Jose Rizal Memorial Center (formerly the Swedish Choral Society) at 1332 West Irving Park Road, Chicago. The momentous occasion took place on June 29, 1974, after an active fundraising campaign to bring about a "dream come true" for the Filipino American community of Chicago. (Alamar Collection.)

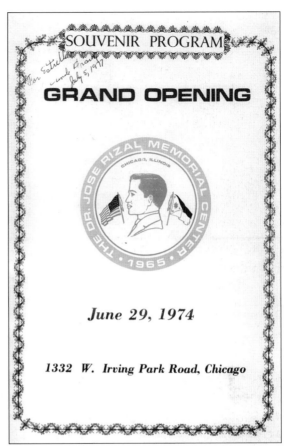

RIZAL CENTER. This is a view from across the street of the Dr. Jose Rizal Memorial Center, looking west. This photo was taken in July 1998. The dream of the first Filipinos settling in Chicago was to have a "clubhouse" of their own. The dream came true in 1974. (Alamar Photograph Collection.)

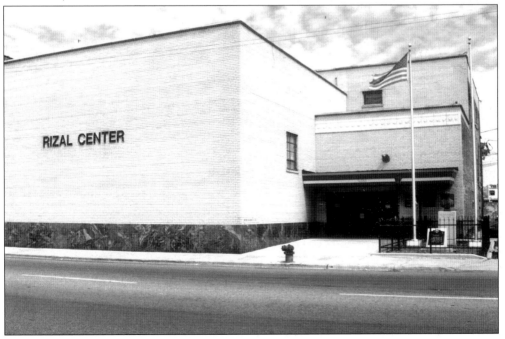

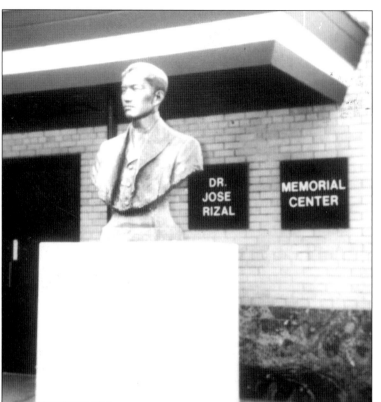

THE DR. JOSE RIZAL SCULPTURE. This photo was taken in April 1992. A fundraising project of the Order of the Knights of Rizal, Chicago Chapter, made the acquisition of the commissioned bust possible. It was designed in Manila as an exact replica of the original, which is enshrined at the national Knights of Rizal headquarters in Manila, Philippines. (Alamar Photograph Collection.)

VISITOR. In August 1997, Atty. Remedios Guiab, Mayor of Wao, Lanao del Sur, Mindanao, visited Rizal Center while here to attend the Sisters City Conference as a Philippines representative. Pictured, from left to right, are Estrella Alamar, Atty. Guiab, and Mrs. Soledad Daelto.

DEDICATION. In December 1994, Irving Park Road was dedicated the honorary name of Dr. Jose Rizal Avenue, from Sheffield Avenue east to Clark Street. The president of the Filipino American Council of Chicago at the time was Dr.Virgilio Jonson. (Photograph by Manny Zambrano)

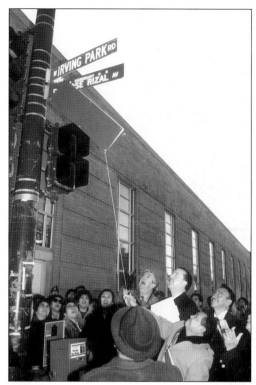

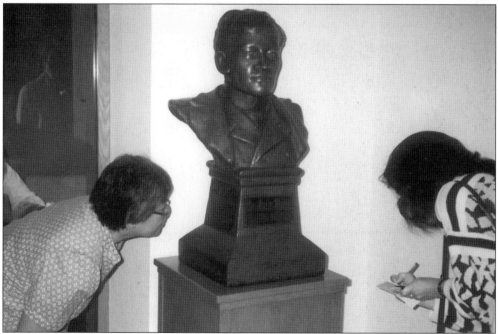

THE BUST OF DR. JOSE RIZAL AT NEWBERRY LIBRARY. The Filipino community donated the Dr. Jose Rizal statue at Newberry Library in the 1920s. A replica stands in the Rizal Room at the Dr. Jose Rizal Center. Estrella Alamar and Dr. Barbara Posadas are reviewing the names of the donors inscribed on the statue.

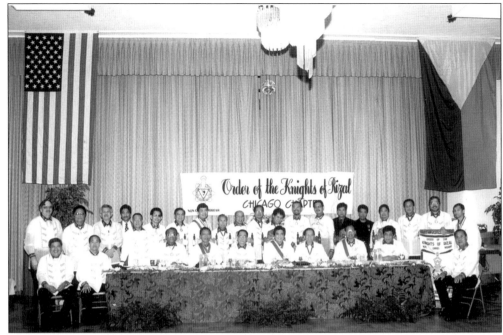

KNIGHTS OF THE ORDER OF RIZAL. The Chicago Chapter was the first K of R in Chicago. This formal picture of the group was taken at Rizal Center in the year 2000, during the Supreme Commander Rogelio Quiambao's visit for the Knights of Rizal Chicago Chapter Induction of new Knights. (Photograph by Manny Zambrano.)

MISS MARIA CLARA. With Miss Maria Clara, from left to right, are Willi Buhay, Widivino R. Buhay, and Jun Rocha.

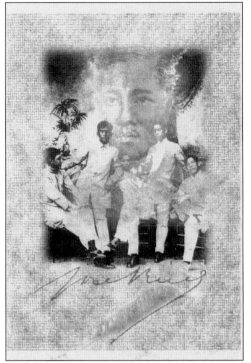

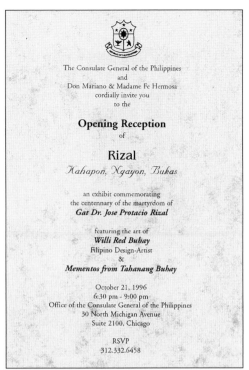

RIZAL, KAHAPON, NGAYON, BUKAS. The opening reception of Rizal Kahapon, Ngayon, Bukas, took place on October 21, 1996, at the Reception Hall "Bulwagan" of the Consulate General of the Philippines, 30 North Michigan Avenue, Chicago. This was a special exhibit featuring the art of Willi Red Buhay in commemoration of the centenary of the martyrdom of Dr. Jose Protacio Rizal.

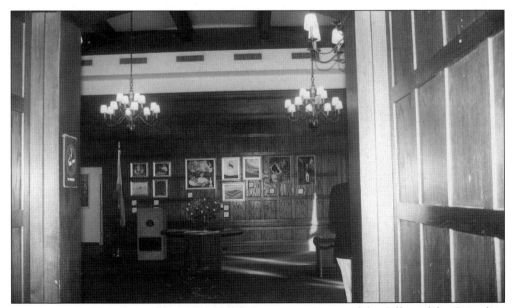

ART EXHIBIT. This photo shows a view of the Reception Room of the Office of the Consulate with the Rizal Exhibit in 1996. (Photograph by Dr. Ruben Red.)

Dr. Jose Rizal Monument Project

Community Mass
Celebrated in Commemoration
of the
138th Birthday of Dr. Jose Rizal
and the
Unveiling of the Dr. Jose Rizal Monument
Saturday, June 19, 1999 - 9:00 a.m.
Marine Drive & Lake Shore Drive
Between Wilson and Lawrence Avenue
Chicago, Illinois

Presider: Rev. Eoli Roselada, OFM

COMMEMORATION EVENT. This is the program cover of the Community Mass, celebrated in commemoration of the 138th birthday of Dr. Jose Rizal and the unveiling of the Dr. Jose Rizal Monument on Saturday, June 19, 1999, at Marine Drive and Lake Shore Drive, between Wilson and Lawrence Avenue. The celebrant was Rev. Eoli Roselada, OFM.

DR. JOSE P. RIZAL TRAVELING MUSEUM. Pictured is the wardrobe of Dr. Rizal on exhibit in Chicago in June 1999. Ms. Patricia Perez, Community Affairs Officer, and John Ablaza, Exhibit Designer, brought the display from the Cebu City Museum in the Philippines.

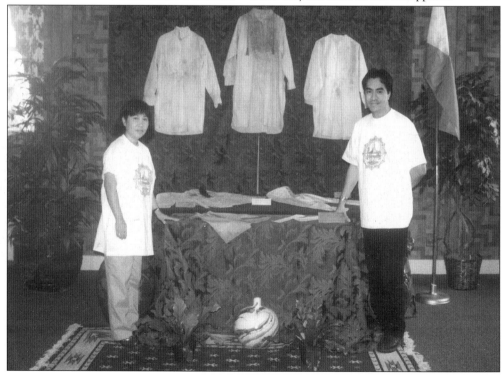

A PLANNING COMMITTEE. Pictured here are some committee members meeting at the park district offices to plan the Rizal Monument installation. From left to right are Dr. Max Basco, Willi Red Buhay (project designer), Dr. Evelyn Natividad, and the park district official.

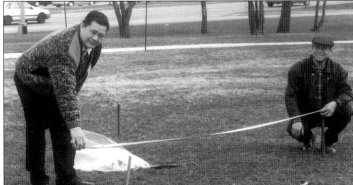

PLANNING. Measuring the grounds in preparation for the monument installation is Ben Gallardo and Willi Buhay. The dedication ceremonies were scheduled for June 1999. (Tahanang Buhay Photograph Collection.)

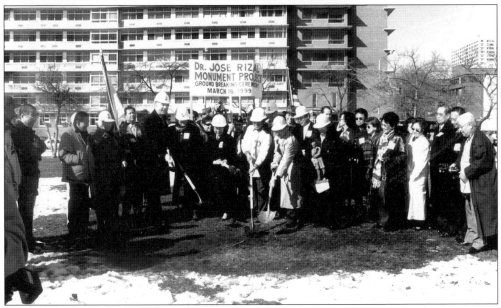

GROUNDBREAKING CEREMONY. This phase of the Dr. Jose Rizal Monument project featured the groundbreaking ceremony headed by the City of Chicago government officials and Filipino American community leaders in preparation of the monument installation. (Alamar Photograph Collection.)

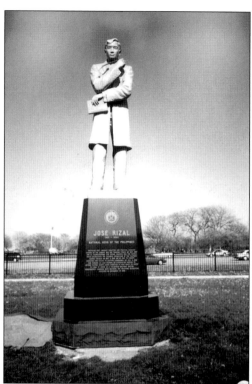

DR. JOSE RIZAL MONUMENT. This photo was taken after the dedication of the Dr. Jose Rizal Monument on June 19, 1999. (Alamar Photograph Collection.)

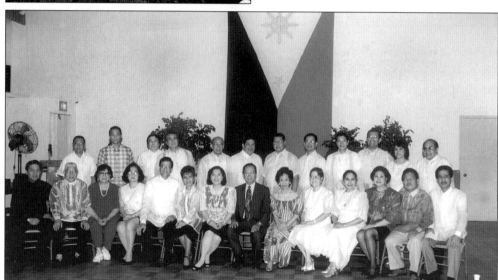

FACC OFFICERS. The 1998–2002 officers of the Filipino American Council of Chicago are pictured here, from left to right: (first row) Vice Consul Adelio Cruz, Joe Sarmiento, Connie Santos, Mila Bensing, President Rey Sapnu, Vice President Mae Lant ,Consul General Emelinda Lee-Pineda, Alfonso Bascos, Paz Saladino, Lita Madridejos, Lydia Rhoton, Carmen Estacio, Toy Mancinido, and Ved Diamante; (second row) Oscar Valdez, Rene Abella, unidentified, Alex Cerera, Tac Florendo, Boni Cenir, Tom Madridejos, Jimmy Alban, Oriel Mojica,Willi Red Buhay, Mila Sapnu, and Rev. Telesforo Yague. (Photograph by Manny Zambrano.)

Eight
FILIPINO-AMERICAN CELEBRATIONS AND COMMEMORATIVE EVENTS

Filipinos love to participate in events—be it a national holiday or a mere town fiesta. There is never a month of the year that goes by without some celebration, party, or commemoration of a significant event.

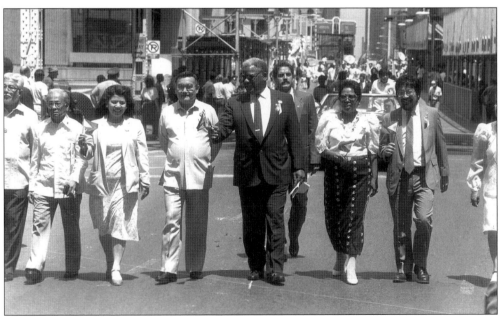

PARADE. Kicking off the Philippine Week Parade in 1980, on Dearborn Street were, from left to right: unidentified, Carmelito Llapitan, Lee Maglaya, Consul General Eleuterio Espina, Mayor Harold Washington, Norma Manankil, unidentified, and Mimi Runo.

FILIPINO GUERRILLAS OF BATAAN ASSOCIATION. This is the program book of the Filipino Guerrillas of Bataan Association Banquet and Ball held on September 19, 1943, at the Drake Hotel in Chicago. President and commander was Col. Jay J. McCarthy. Headquarters location was 139 North Clark Street, Chicago.

FILIPINO GUERRILLAS OF BATAAN ASSOCIATION BANQUET. This photo was taken on September 19, 1943, at the Drake Hotel, Chicago. (Mr. and Mrs. Alfredo Acierto Photograph Collection.)

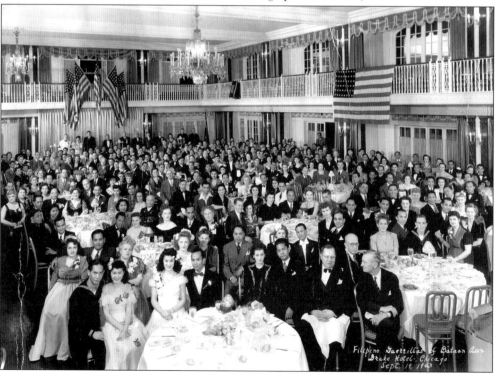

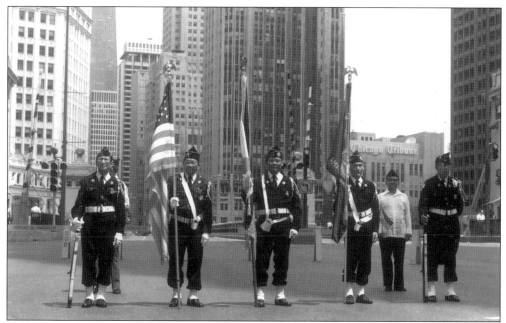

FILIPINO POST NO. 509. The Color Guard of the American Legion Filipino Post No. 509 is shown participating in the Philippine Week Parade in 1983, on Michigan Avenue. From left to right are Jimmy Aguilar, Sotero Parpana, Justo Alamar, Victor Orina, and Louis Asanon.

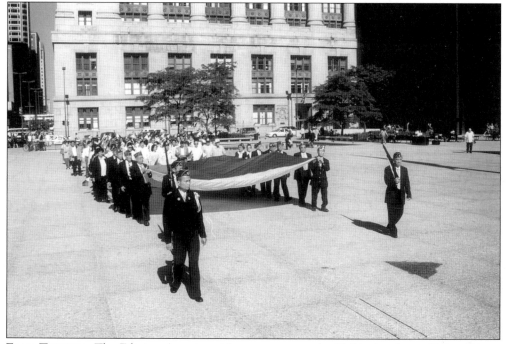

FLAG TRIBUTE. The Filipino American Veterans present the Philippine flag at Daley Center during the flag raising ceremony on Kalayaan Day, June 12, 1999. (Tahanang Buhay Photograph Collection.)

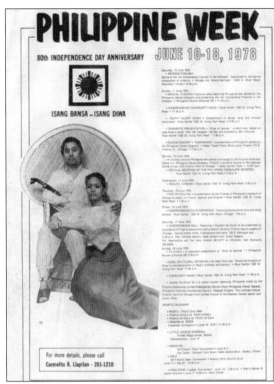

PHILIPPINE WEEK, JUNE 10–18, 1978. This announcement shows the calendar of events for the Philippine Week celebration. Pictured is Atty. Ben Albovias, depicted as Dr. Jose Rizal in the play, *Elias at Salome.*

PHILIPPINE PRESIDENTIAL VISIT. This is a 1956 *Chicago Tribune* photo of a reception for President Carlos Garcia, who is pictured with Mayor Richard M. Daley and Consul General Sofronio Abrera. Performers of the Tinkling Dance are Remedios Gonzales, Kitty Vitor, and Ray Tolentino. (*Chicago Tribune* Photograph, Gonzales Photograph Collection.)

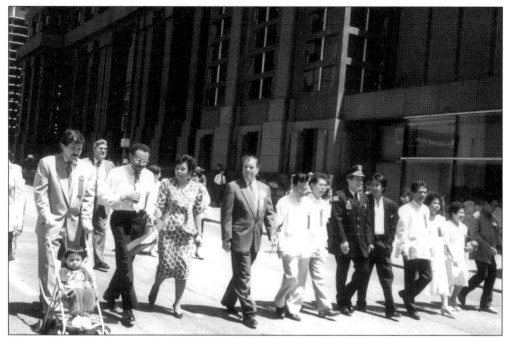

PHILIPPINE WEEK PARADE, 1993. Pictured kicking off the Philippine Week Parade of 1993, from left to right, are Cook County Clerk David Orr, Roland Burris, Commissioner of Sewers Teresita Sagun, Mayor Richard J. Daley, Consul General Dr. Jaime Bautista, Rudy Tapalla, and other Filipino American community leaders.

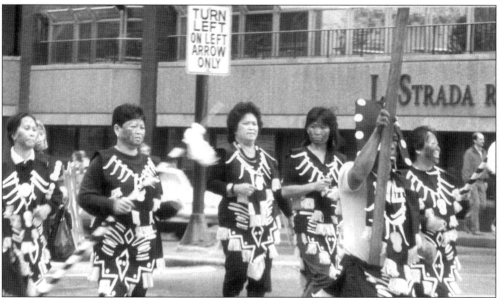

ATI-ATIHAN. The Ati-Atihan, or the Feast of the Atis (*Aetas*), marks the beginning of the Feast of the Santo Niño. The tradition was born in Kalibo, Aklan, where participants mask their faces, soot their bodies with ashes, and wear fanciful costumes depicting the native *atis*. With the beating of the drums and sticks, they parade the streets with merriment as they did in this Philippine Week parade. (Alamar Photograph Collection.)

99

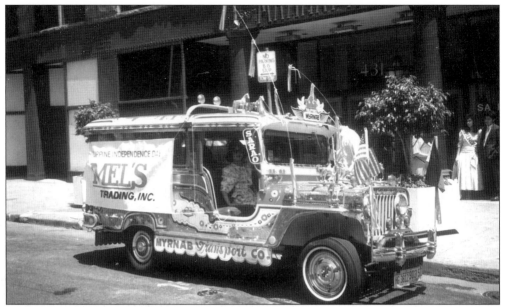

JEEPNEY. This jeepney, sponsored by Mel's Trading, Inc., was used in the Philippine Week Parade in June 1988. The jeepney, a Filipino invention, is a converted army jeep of the World War II period. The fanciful and whimsical decoration is inspired by the folk colors and designs found in many Filipino Folk Arts. (Alamar Photograph Collection).

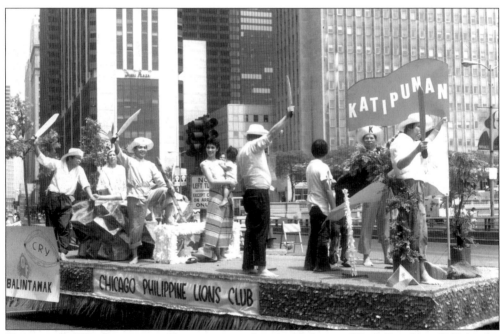

KATIPUNAN. The float pictured here, sponsored in the Philippine Week Parade in 1983 by the Chicago Philippine Lions Club, depicts the Katipunan. The Katipunan refers to the brotherhood during the Spanish-Filipino Revolution, where thousands of Filipinos died for freedom. The revolution was nationwide. The Filipinos won freedom until the coming of the Americans, who took over the islands and people.

ASIAN-AMERICAN HERITAGE MONTH. In commemoration of Asian American Heritage Month in May 1990, Filipino American employees of the Chicago Transit Authority (CTA) exhibited the history of the Filipino American community at the CTA headquarters at the Merchandise Mart Plaza.

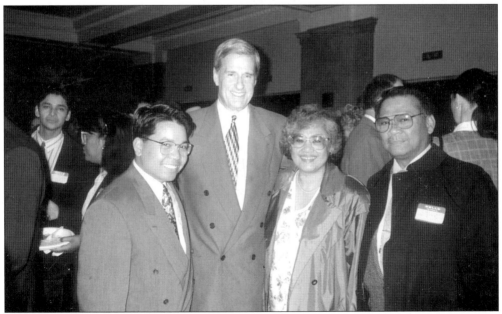

ASIAN-AMERICAN HERITAGE MONTH. Some offices of the City of Chicago and Cook County celebrate the heritage of the diverse ethnic groups of the area annually. Shown here at a history exhibit is the Commissioner of Cook County, Richard J. Phelan, with Matthew De Leon, Estrella, and Justo Alamar.

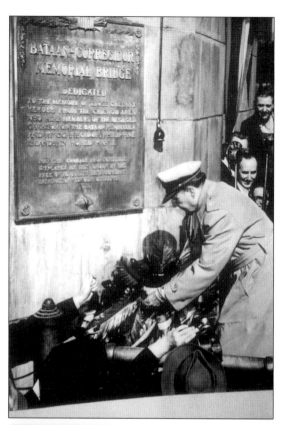

A HERO'S TRIBUTE. Shortly after General Douglas MacArthur's tour of duty in Asia, he visited Chicago. While here, he visited the Bataan-Corregidor Bridge at State Street and Wacker Drive to pay tribute to the veterans. A motorcade to Soldier Field and a program to welcome the general also took place at Soldier Field.

VETERAN'S TRIBUTE. Filipino-American veterans pay tribute to their comrades at the Bataan-Corregidor Bridge during the Bataan-Corregidor Commemoration May 1992. (Alamar Photograph Collection,)

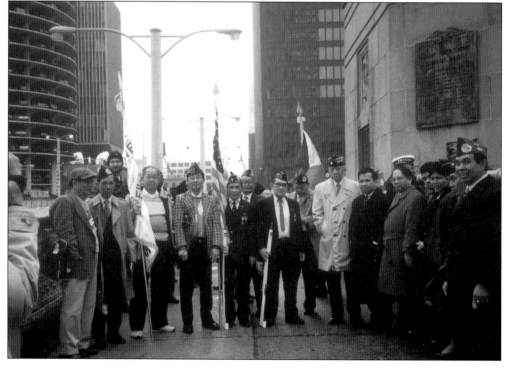

EDUCATIONAL ACHIEVEMENT RECOGNITION AWARDS CEREMONY. The ceremony was held for Philippine Educators in America, Chicago Chapter. Shown here is the program book for August 5, 1984.

FILIPINO AMERICAN COUNCIL OF CHICAGO

Philippine Educators in America - Chicago Chapter

pea

EIGHTH ANNUAL EDUCATIONAL ACHIEVEMENT RECOGNITION AWARDS CEREMONY

Sunday, August 5, 1984 at 2:30 P.M.

RIZAL COMMUNITY CENTER

1332 West Irving Park Road, Chicago, Illinois

GRADUATE HONOREES. This occasion was an annual program by the Philippine Educators in America organization at the Rizal Center. President Romeo C. Gatan, along with the Filipino American community, honored Filipino-American graduates for their academic achievements at the eighth grade, high school, and college levels.

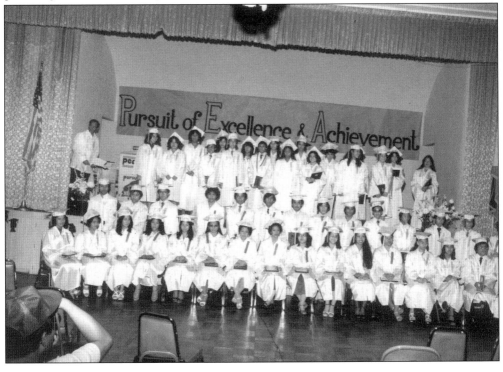

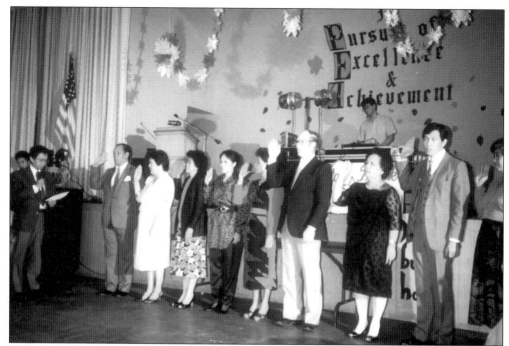

PEA Installation of Officers. In the colorful decorated auditorium of the Dr. Jose Rizal Center, the Philippine Educators in America in 1986 had the Installation of Officers Oath Ceremony. From left to right are Atty. Alfonso Bascos (administering the oath), President Romeo Gatan, unidentified, unidentified, Lardizabal, Flor Gatan, James Kennedy, Dorie Pena, Antonio Amante, and Estrella Alamar.

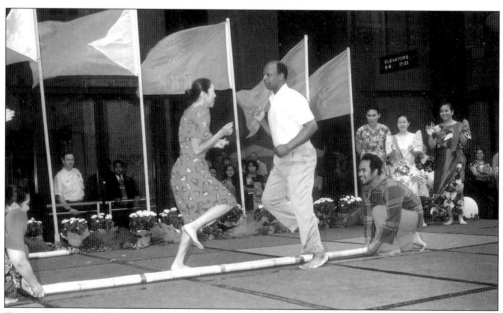

Tinkling. At the Kalayaan celebration in June 1999, at Daley Plaza, Secretary of State Jesse White joined the Kultura Filipina Dancers in performing the Tinkling Dance. Tinkling is a dance simulating the black bird jumping over clapping bamboo poles.

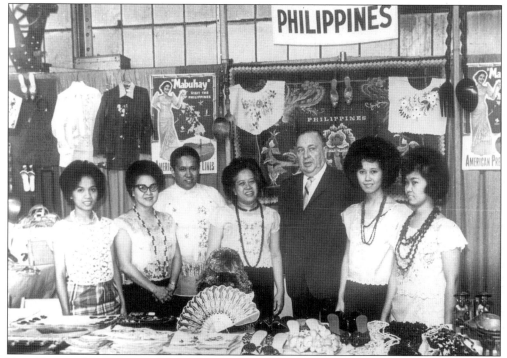

FOLK FAIR AT NAVY PIER. This picture was taken in October 1966. The Chicago International Folk Fair held at Navy Pier was a popular ethnic attraction of the City of Chicago for many years. Greeting Mayor Richard M. Daley at the Philippine Bazaar, from left to right, are Julie Aragon, Pompeia Lavado, Alex Gonzales, Julie Cruz, Mayor Daley, Flora Borja, and an unknown volunteer.

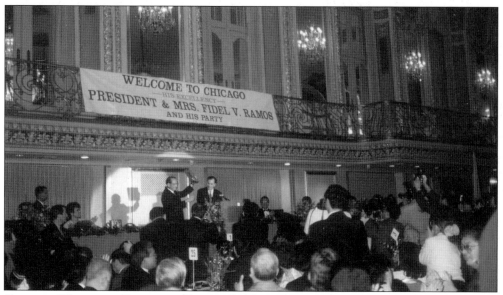

CHICAGO WELCOMES PRESIDENT RAMOS. In November 1993, Mayor Richard J. Daley joined the Filipino American community at the Hilton Towers to welcome the president of the Philippines, Fidel Ramos.

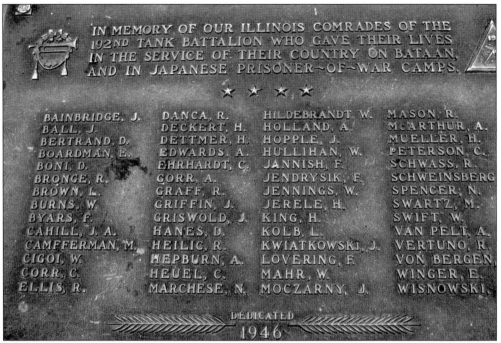

MEMORIAL. The memorial plaque pictured here was dedicated in 1946, in Maywood, Illinois. It reads, "In memory of our Illinois comrades of the 192nd Tank Battalion who gave their lives in the service of their country on Bataan and in Japanese Prisoner-of-War camps." The plaque is enshrined in a memorial site at Maywood Park, Maywood, Illinois.

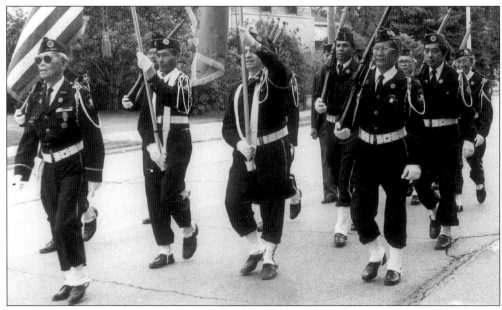

MAYWOOD BATAAN DAY PARADE. The American Legion Filipino Post No. 509 color guard is pictured marching in Maywood, Illinois, in September 1980. From left to right are Salvador Cepeda, Justo Alamar, Victor Orinia, Sidney Altman, Robert Mittenthal, Jimmy Aguilar, and Robert Alamar.

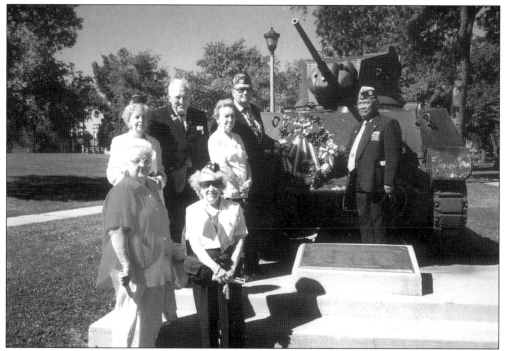

TRIBUTE TO BATAAN. Every second Sunday of September, a memorial service is held at Maywood Park, Maywood, Illinois, in tribute to the Bataan veterans of World War II and the veterans of other conflicts. Some of the Maywood Bataan Organization members pictured in September 1995 are Edwin H. Walker IV, Jo Becker, Michael Dravo, and President of the Maywood Bataan Organization, Justo O. Alamar.

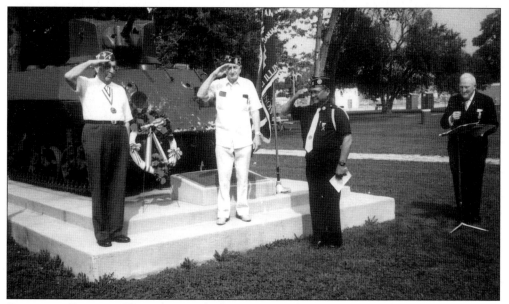

SALUTE TO BATAAN. This tribute took place in September 1997. Pictured from left to right are Dr. Yonan; unidentified; President of the Maywood Bataan Organization, Justo O. Alamar; and Edwin H. Walker IV.

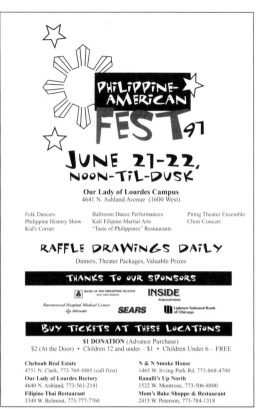

PHILIPPINE-AMERICAN FEST 97

JUNE 21-22,
NOON-TiL-DUSK

Our Lady of Lourdes Campus
4641 N. Ashland Avenue (1600 West)

Folk Dancers · Ballroom Dance Performances · Pintig Theater Ensemble
Philippine History Show · Kali Filipino Martial Arts · Choir Concert
Kid's Corner · "Taste of Philippines" Restaurants

RAFFLE DRAWINGS DAILY
Dinners, Theater Packages, Valuable Prizes

THANKS TO OUR SPONSORS
BANK OF THE PHILIPPINE ISLANDS NEW YORK BRANCH · **INSIDE** PUBLICATIONS
Ravenswood Hospital Medical Center Advocate · **SEARS** · Uptown National Bank of Chicago

BUY TICKETS AT THESE LOCATIONS
$1 DONATION (Advance Purchase)
$2 (At the Door) • Children 12 and under – $1 • Children Under 6 – FREE

Cheboub Real Estate
4751 N. Clark, 773-769-4485 (call first)
Our Lady of Lourdes Rectory
4640 N. Ashland, 773-561-2141
Filipino Thai Restaurant
5349 W. Belmont, 773-777-7760

N & N Smoke House
1465 W. Irving Park Rd, 773-868-4700
Ranalli's Up North
1522 W. Montrose, 773-506-8800
Mom's Bake Shoppe & Restaurant
2415 W. Peterson, 773-784-1318

PHILIPPINE AMERICAN FEST. During the weekend of June 21–22, 1997, the Philippine-American Fest showcased the talents of members of various Filipino-American groups in a variety of events and programs at Our Lady of Lourdes Church.

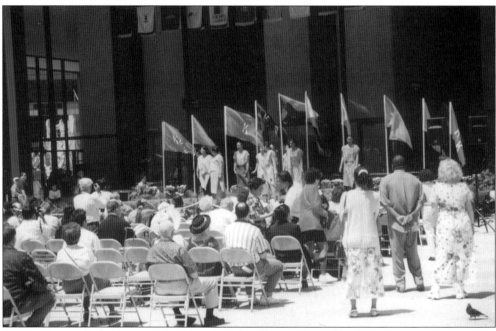

DALEY PLAZA. In the heart of the Loop at Daley Plaza on June 12 of every year, one may enjoy a Philippine show and cultural exhibit in celebration of the 1898 proclamation of Philippine independence. In the picture on stage are performers from the Filipino-American community.

Nine

SOCIAL AND PROFESSIONAL ORGANIZATIONS

The Filipinos have transferred from the old country the strong sense of "community" to their everyday American life. It is typical to belong to more than one organization or club. It is also typical to form a number of new organizations to meet the changing needs of the individuals or groups of individuals in the community.

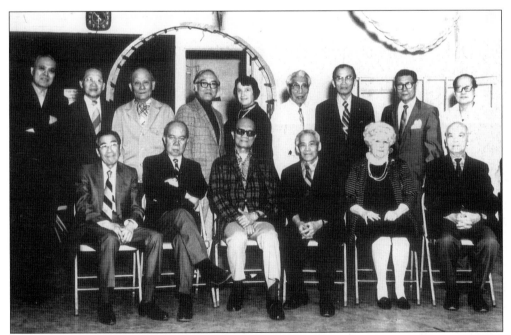

SENIOR CITIZEN'S CLUB. The pioneering Filipinos formed the Filipino American Senior Citizens Club when they attained their retirement age. This picture was taken in April 1975, at the Webster clubhouse. From left to right are: (standing) unidentified, unidentified, unidentified, Mariano and Susan Vitor, unidentified, unidentified, unidentified, and unidentified; (seated) Valentin Daclan, Silverio Sol, Jose Leonidas, Rev. Fermin Runas, unidentified, and unidentified.

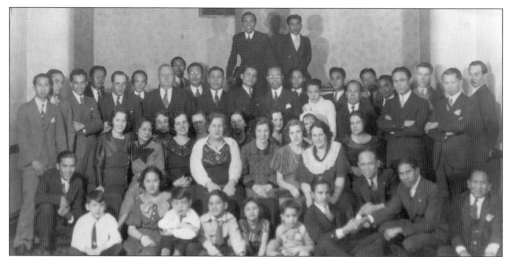

NEW YEAR'S EVE PARTY. The Filipino Gibbons Society is one of the community's oldest clubs. It later became known as the Catholic Filipino American Guild. This picture was taken at a New Year's Eve Party to celebrate the incoming year, 1935. (Julie Dumo Photograph Collection.)

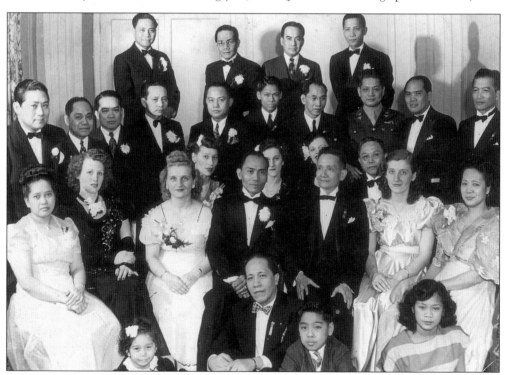

ZAMBALES CLUB. The Zambales province is near the Mt. Pinatubo volcano. This December 29, 1946, party welcomed special guest, Dr. M. Gamboa. Pictured from left to right are: (top) unidentified, Braulio Abrajano, Rosauro Cruz, and Simon Factora; (middle) Frank Afable, unidentified, Alejandro Gonzales, unidentified, Silvino Hernandez, Justo Alamar, unidentified, Dr. Francisco Duerme, Eugene Estacion, unidentified, Julie Cruz, Helen Afable, Sophie Abrajano, unidentified, Richard Labrador, unidentified, Necitas Alamar, Helen Valente, Gregoria, Alamar, Benny Feria, and Robert and Joy Alamar. (Alamar Photograph Collection.)

110

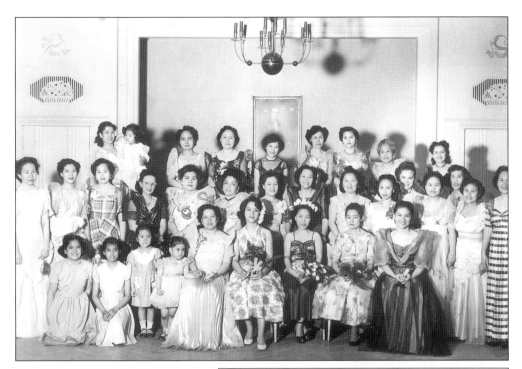

FLORES DE MAYO. This is a photograph of the 1953 Filipino American Women's Club Flores de Mayo. The group seen in the picture is made up of Filipinas of the pioneering generation and the war brides who came to the United States after 1946. (Ravelo Photograph Collection.)

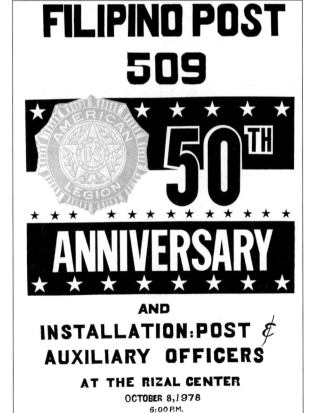

FILIPINO POST 509

★ ★ ★ ★ ★

50TH

★ ★ ★ ★ ★ ★ ★ ★ ★ ★ ★

ANNIVERSARY

★ ★ ★ ★ ★ ★ ★ ★ ★

AND

INSTALLATION: POST &

AUXILIARY OFFICERS

AT THE RIZAL CENTER

OCTOBER 8, 1978

6:00 P.M.

FIFTIETH ANNIVERSARY. The American Legion Filipino Post No. 509 was originally organized as the Tomas Claudio Post in 1928. Members of the Post and Auxiliary continue to be active in the A.L. First Division and Sixth District Council. The 50th Anniversary was celebrated on October 8, 1978, at the Dr. Jose Rizal Center. (Alamar Collection.)

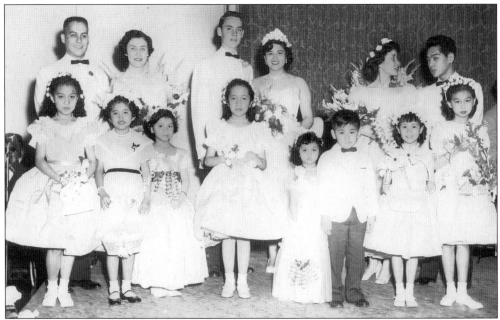

FLORES DE MAYO. This photograph shows the Flores de Mayo celebration of the Filipino American Women's Club in May 1956. Pictured, left to right, are (top) Mr. Aguila, Angeline de Castro, unidentified, unidentified, Marilyn Manuel, and Robert Alamar. The younger ones, left to right, are Rosemarie Dacanay, unidentified, unidentified, unidentified, Ethel and Ronald Viernes, and unidentified. (Alamar Photograph Collection.)

PHILIPPINE STUDY GROUP (PSG). Members are shown here at a weekend outing in May 1977, at Williams Bay, Wisconsin. (Alamar Photograph Collection.)

112

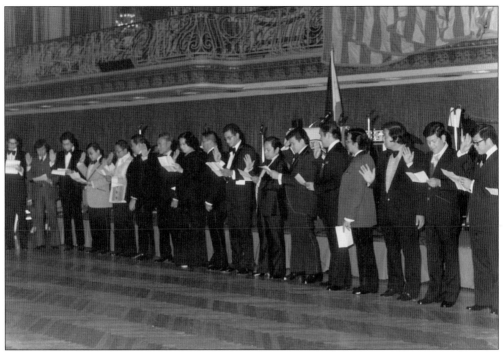

PHILIPPINE MEDICAL ASSOCIATION. Established in the 1960s, the Philippine Medical Association was organized by the doctors to foster professional growth and development in the specialized medical fields. The Installation of Officers is a traditional ritual at organization social events. (Llapitan Photograph Collection.)

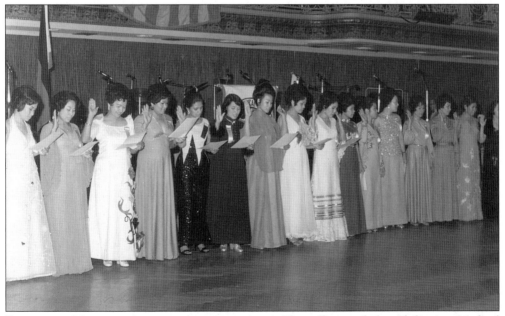

PHILIPPINE MEDICAL ASSOCIATION AUXILIARY. The officers of the Philippine Medical Association Auxiliary are pictured during their installation ceremony. (Llapitan Photograph Collection.)

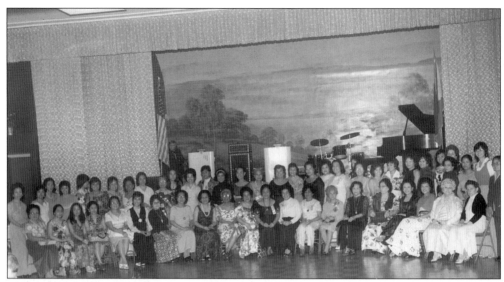

FILIPINE AMERICAN WOMEN'S CLUB. This photo was taken in May 1975. Documents recorded Mrs. Julita Cruz as the outgoing president and Mrs. Angelita Llapitan as the new president. Special guest at the celebration was Mrs. Suarez. (Llapitan Photograph Collection.)

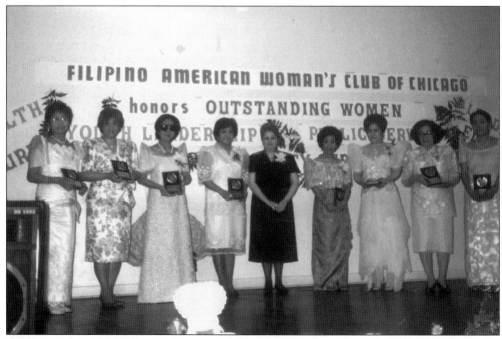

FILIPINE AMERICAN WOMEN'S CLUB OF CHICAGO. This photo was taken in May 1993 at the Dr. Jose Rizal Center. Under the presidency of Mrs. Araceli Somera, the Filipino American Women's Club honored outstanding women in the community. (Alamar Photograph Collection.)

114

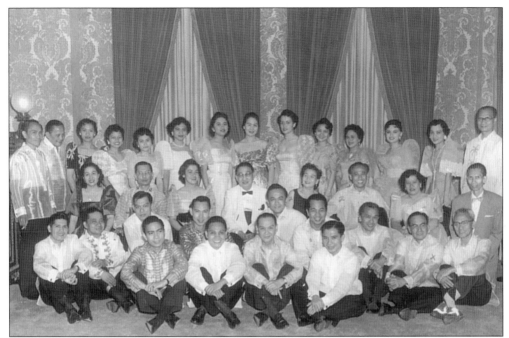

RIGODON DE HONOR. For this photograph of a special occasion, the men and women are pictured in their best Philippine costume designs. They are participating as partners in the traditional dance, Rigodon de Honor. It is a quadrille participated in by distinguished members of the community, oftentimes dancing at official state affairs. (Photograph by the De La Paz Studio.)

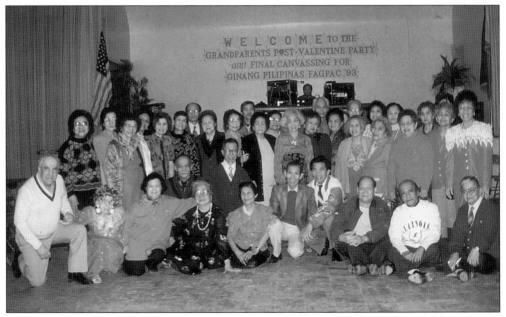

VALENTINE PARTY. Photographed here are the Grandparents Club members celebrating at a post-Valentine party in February 1993. (Photograph by Edna Pavel.)

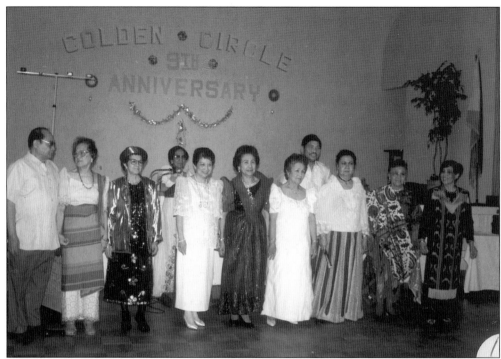

ANNIVERSARY PARTY. In May 1997, the members of the Golden Circle commemorated the club's ninth anniversary. A fashion show of traditional costumes was the highlight of the evening.

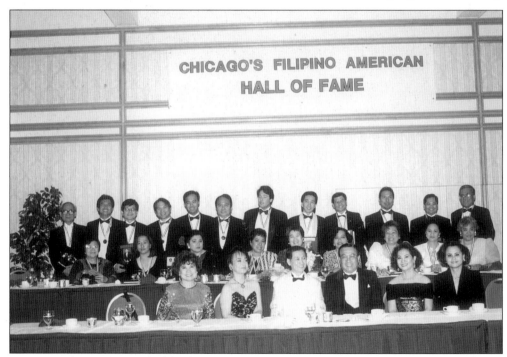

HALL OF FAME. Distinguished leaders in the Filipino-American community were presented at Veronica Leighton's Via Times Filipino American Hall of Fame.

SIMBANG GABI. Shown here is a copy of the Mass program designed by Willi Red Buhay for the Simbang Gabi, the traditional nine-day Novena in honor of the Holy Nativity of Jesus Christ. It was held at Holy Name Cathedral on December 15, 2000. Cardinal George was the main celebrant. (Tahanang Buhay Collection.)

Simbang Gabi 2000

"Listening to God's Words and Conversion"

December 15, 2000
Holy Name Cathedral
Archdiocese of Chicago

Celebrant:
Rev. Robert E. McLaughlin, Pastor

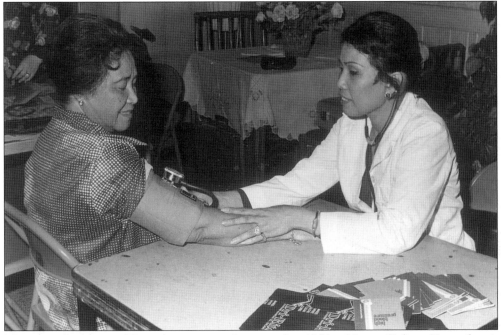

MEDICAL SERVICES. This photo was taken in the 1980s. Nurse Geline Tanquilut is administering a blood pressure check to Mrs. Ann Llapitan during one of the health screenings conducted at the Dr. Jose Rizal Center. Free health screenings are one of the services offered annually to senior citizens. (Llapitan Photograph Collection.)

PRIZE-WINNING PAINTING. For the 1993 Asian American Heritage Month, Willi Red Buhay received the State of Illinois award for his artwork. The poster, distributed throughout the United States, depicts the early immigration experience of a pioneer *Manong* preparing his dinner under the stars in an outback kitchen. (Tahanang Buhay Collection.)

POPULAR NEWSPAPER. Orlando "Orly" Bernardino is one of the established journalists of the Filipino-American community. *The Philippine Weekly* is distributed in the city and suburbs weekly. It covers local and international news in English and Tagalog.

Ten

FILIPINO-AMERICAN HISTORICAL SOCIETY OF CHICAGO AND FAHSC MUSEUM

Mission Statement:

To record the Filipino American history in the Chicago area.

To preserve selected artifacts and documents of that history.

To provide exhibits "Just Yesterday" and "Kindred Spirit—Waves Apart," the history of Chicago's Filipino Americans.

To provide the art exhibit, "Family Tree of Filipino Immigration," depicting the historical themes of Filipino immigration to the United States.

To promote public interest in the history of Chicago's Filipino Americans.

To educate and involve individuals and groups in an appreciation and understanding of the Philippine heritage of Chicago's Filipino Americans; and

To establish the Filipino American Historical Society of Chicago Museum.

Planting a seed in fertile soil is not enough—
One has to water it and nourish it to let it grow.
To grow is not enough.
One has to nourish it so it may bloom and bear fruits.

March 13, 1999
Willi Red Buhay

Our vision is to have the Filipino American Historical Society of Chicago Museum grow to fulfill the mission of the Filipino American Historical Society of Chicago.

JUST YESTERDAY. The poster is an announcement of the first "Just Yesterday" exhibit, the history of Chicago's Filipino Americans from the 1920s to the 1950s. The exhibit took place in 1983 at the Rizal Center. Estrella Alamar, as president of the Nueva Vizcaya Association, initiated the project, which years later became one of the main features of the FAHSC Museum.

JUST YESTERDAY IN THE PHILIPPINES. This cover, now a historical document, records the presentation of the "Just Yesterday" Exhibit in the Philippines in 1985, at the Hyatt Hotel and the Philippine Cultural Center. The exhibit was sponsored by Philippine Airlines to celebrate the inauguration of direct flights between Chicago and Manila.

FAHSC MEMBERS. The founding members of the Filipino American Historical Society of Chicago were mostly second-generation, American-born Chicagoans. Some of them are pictured here at the Filipino American Women's Network Conference, held at the University of Chicago campus in 1988. (Alamar Photograph Collection.)

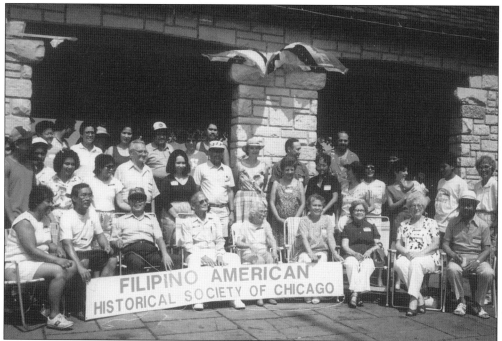

FAHSC Reunion picnic. After more than 25 years, this was the first reunion of the pioneer seniors and their second and third-generation offspring. It was held at the 55th Street Promontory by Lake Michigan, with a sharp view of downtown Chicago to the north and Indiana on the south. There was plenty of good food and all-around fun! (Alamar Photograph Collection.)

Pinoy Walk. Walking from the Shedd Aquarium, past Buckingham Fountain, to Randolph Street, the *Pinoy* walkers raised funds for the Filipino American Historical Society of Chicago. Pictured in 1991, showing off the T-shirts, are Arlene del Rosario, Susan Paiso, Estrella Alamar, Phoebe and Jay Cabanban. (Alamar Photograph Collection.)

FAHSC Pansitfest. The third Filipino American Historical Society Pansitfest was held in 1997, at the Rizal Center. Among those present to savor the different *pansit* dishes were, from left to right, Pompeia Lavado, Elvira Bacalzo, Julie Dumo, Millie Santos, Dick Snoody, Ramona Viernes, Pearl Snoddy, Caroline Manalo, Connie Santos, and Estrella Alamar. Justo Alamar took the picture. (Alamar Photograph Collection.)

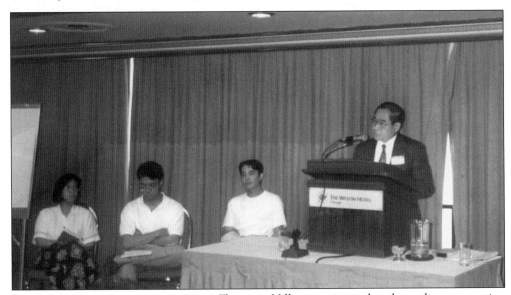

Fanhs-Midwest Conference, 1993. Florencio Villegas is pictured at the podium presenting his immigration story at the history workshop. He came to Chicago in the 1950s as a teenager. Another participant pictured is Dennis Emano (second from left). The conference was held at the Westin Hotel on Michigan Avenue.

FOURTH FANHS CONFERENCE.
Pacifico Bacalzo designed the logo
on the program book for the Filipino
American National Historical
Society Conference, held in Chicago
in July 1992. It featured the fusion of
Filipino and American landmarks
and symbols and signifies the arrival
of Filipinos to America in different
immigration waves or periods.

Filipino American National Historical Society

FOURTH NATIONAL CONFERENCE

July 2 - 4, 1992
Westin Hotel
Chicago, Illinois

"Kindred Spirit - Waves Apart"

Hosted By The
FILIPINO AMERICAN HISTORICAL SOCIETY OF CHICAGO

GUEST SPEAKERS. Pictured are Dorothy Cordova, Fred Cordova, and Dr. Barbara Posadas at
the Fourth FANHS Conference at the Westin Hotel, Chicago, in July 1992.

GUEST SPEAKERS. Pictured are Dr. Virgilio Pilapil, Dr. Alan Bergano, and Rev. Anthony Vader at the Fourth FANHS Conference.

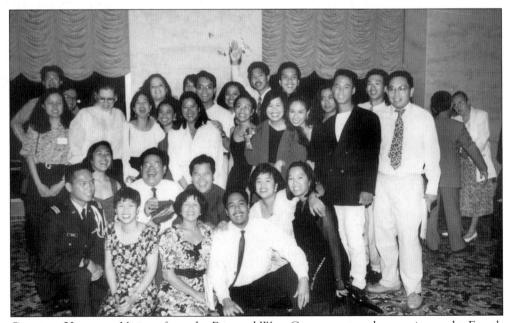

CHICAGO VISITORS. Visitors from the East and West Coast wrap up the evening at the Fourth FANHS Conference with a group picture for a remembrance.

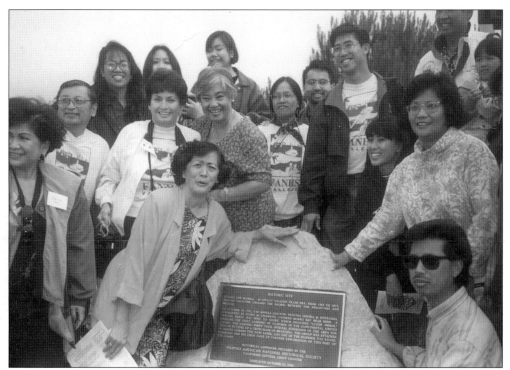

VISIT TO MORRO BAY. The Illinois representatives at the dedication of the historic site honoring the arrival of Filipinos to America at Morro Bay, California, in 1987 were Virgilio and Elena Pilapil, Mildred Santos, and Estrella Alamar.

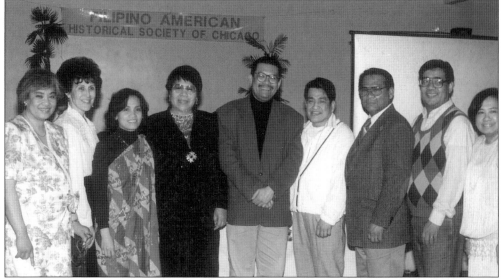

ANNIVERSARY EVENT. Commemorating the 225th Anniversary of the Filipino presence in America at a Filipino American Historical Society of Chicago program at Rizal Center were, from left to right, Estrella Alamar, Angeline Ali, Deyi Fidel, Fe Villanueva, Willi Buhay, Hercules Auza, Justo Alamar, Rey Lopez, and Edna Montemayor. (Alamar Photograph Collection.)

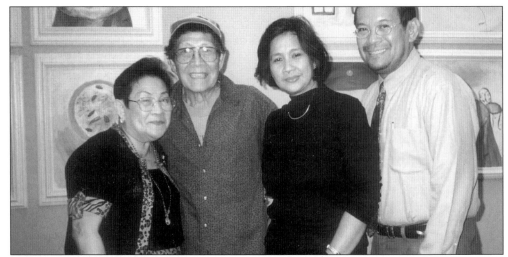

ERBU. In August 1999, the Filipino American Historical Society of Chicago Museum opened with a special art exhibit by Wivinne Buhay-Javier, also known as ERBU. Family members pictured at the event, from left to right, were Delia Buhay de la Rosa, Dr. Ruben Red, ERBU, and Willi Buhay. (Alamar Photograph Collection.)

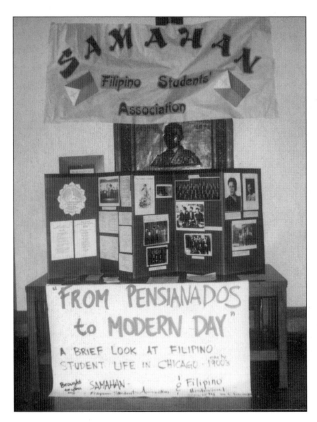

SAMAHAN DISPLAY. The University of Chicago student organization, SAMAHAN, arranged for a miniseries of history exhibits displayed by the Filipino American Historical Society of Chicago. This photo shows one of the displays in November 1997. (Alamar Photograph Collection.)

Moo Moo, The Philippine Cow. Shown with "Moo Moo, the Philippine Cow" are its artists, Willi Red Buhay and Wivinne Buhay Javier (ERBU), at Michigan Avenue near Washington Street. This was its summer location during the August 1998 Chicago Department of Tourism's "Cows on Parade." Moo Moo is presently on display at its sponsor's site, the Filipino American Historical Society of Chicago Museum. (Tahanang Buhay Photograph Collection.)

North Lakeside Cultural Center, November 1998. Before the founding of the FAHSC Museum, cultural events of the Filipino American Historical Society of Chicago were held at the North Lakeside Cultural Center at 6219 North Sheridan Road, Chicago.

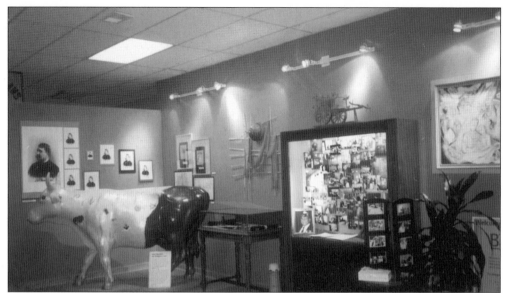

FILIPINO AMERICAN HISTORICAL SOCIETY OF CHICAGO MUSEUM. The museum was opened in March 1999. The official ribbon-cutting ceremony took place on October 13, 1999. Co-founders are Estrella Alamar and Willi Buhay. Many loyal supporters made the establishment of a museum come true.

CULTURAL CONNECTIONS. Since its opening, the Filipino American Historical Society has participated in the Field Museum's Cultural Connections programs. FAHSC museum curator, Willi Buhay, is seen here describing the collage of paintings entitled, "Family Tree of Filipino Immigration." The photo was taken on March 13, 1999. (Photograph by Field Museum photographer.)